Professional Fashion Photography

Professional

Fashion Photography

Up-dated and Expanded Edition

Robert Farber

AMPHOTO
American Photographic Book Publishing
An imprint of Watson-Guptill Publications
New York, New York

In memory of Norman Farber
This one's for you, Dad . . .

New edition published 1983 in New York, New York by
American Photographic Book Publishing: an imprint of
Watson-Guptill Publications, a division of Billboard Pub-
lications, Inc., 1515 Broadway, New York, N.Y. 10036.

Library of Congress Catalog Card Number 78-15833
ISBN 0-8174-2440-7
ISBN 0-8174-5549-3 pbk.

Manufactured in the United States of America

1 2 3 4 5 6 7 8 9/86 85 84 83

Acknowledgments

I wish to give special thanks to the art directors and editors whose assignments made this book possible. This is a partial list of the people without whose help this book would not be possible:

Carol Barnstead
Anne Bezamat
Geoffrey Beene
Jacques Bellini
Bill Berta
Elizabeth Biondi
Leland Bobbe
Michele Bontemp
Joe Brooks
John Casablancas
Harold Center
Harry Coulianos
Wendy D'Amico
David Davidian
Elite Models Inc.
Kelly Emberg
Max Evans
Charlotte Farber
Judith Farber
Lee Farber
Ford Models Inc.
Don Goddard
Robin White Goode
Ellen Greene
Yves Claude Hair
Gloria Hall

Iman
Jayne Ingram
Ellen Johnson
Rowan Johnson
Harvey Kahn
David Leddick
Legends Models Inc.
Gary Lowe
Richard Martino
Brian D. Mercer
Debbie Milobrath
Michael O'Connor
John Oppido
Trudy Owett
Monique Pillard
Victor Podesser
Virginia Podesser
Leonard Restivo
Janet Rogler
Rich Sammon
Tom Smallwood
Martin Snaric
Alan Sprules
Techo
Wilhelmina Models Inc.
Zoli Models Inc.

In every industry there are those people whose strength of character and personality make them a pleasure to work with. In the fashion industry, Zoltan Rendessy (Zoli), was one such person. He will always be remembered.

Contents

Introduction

Fashion photography has attracted some of the most brilliant photographers of the twentieth century. Its byword is "glamour," or, as the dictionary defines it, "a strangely alluring atmosphere of romantic enchantment," populated by beautiful models, high-powered executives, and highly creative people of all sorts, including art directors, fashion editors, fashion designers, hair and cosmetic stylists, and the photographers themselves. It is a profession in which the photographer stands at the nexus of an extremely complex set of relationships among clothing and cosmetic manufacturers, advertising agencies, fashion magazines, and the public. He bears the ultimate responsibility for actually producing the image that may have been planned for months by an ad agency for a client, or by an art director for a magazine—an image that may ultimately be seen by millions of people in a magazine or on a package or billboard.

Despite the dynamic appeal of the subject and the romantic image that has been projected in movies and novels, very little has been written about how a fashion photographer actually functions as a professional. What is the process that leads to the point where the scene has been set, the model posed, and the photographer poised to press the shutter-release button on his camera? What actually goes on behind the scenes between the photographer and the advertising executives, the clients, the fashion editors, the models, the stylists, and the other people he works with day in and day out? Few books on the subject include any mention about the business and art of fashion photography; rather, most are concerned with the technical aspect: how to light a subject, what equipment to use, how to set up a studio—information that is useful and necessary but limited in its value as a description or assessment of the field as a whole.

In putting together this book, I have kept in mind those questions which I have been asked most frequently by beginning photographers, as well as those which I myself had asked before entering the field. Such questions, while seldom of a technical nature, do recur repeatedly and, taken together, define the profession itself. Examples: What are the differences between editorial and advertising fashion? How do these differences affect the photographer's approach to a particular assignment, the freedom he has in planning the pictures, and the amount of money he is paid? What is involved in actually shooting an assignment, in hiring models, in finding locations, in establishing fees, and in directing a whole band of creative and sometimes temperamental people? What is important in putting together a portfolio and in presenting it to art directors and fashion editors? How does a photographer get his foot in the door in the first place? How does a photographer maintain his own artistic growth and infuse new ideas in his work?

In attempting to answer these questions, I have relied on my own view derived from inside the world of fashion photography, based on my own experiences and expressed through the pictures that have resulted from assignments in both editorial and advertising fashion. In the end, a photographer owes his success to his talent with the camera. But, he also has to deal with myriad situations—social, financial, managerial—that have nothing to do with his aesthetic ability, and it is upon these aspects of the profession that this book is focused.

The Direction of Fashion Photography

Pictures cover the world. They compete with and define how we look at, feel, and think about reality, filling our horizons in magazines and newspapers, on television and movie screens, on product packages and billboards, subways, buses, and stadium scoreboards, and a host of other visual media that are with us every day. Whereas pictures through the nineteenth century were static and confined to books and objects of art, they have, since the beginning of the twentieth century, become increasingly ubiquitous and all-encompassing, particularly in the form of photographic reproduction. The modern era is one of photocommunication which creates a network of images that complements and sometimes overwhelms the real world.

A large part of that network, especially in the United States, has been taken up by advertising, reflecting and contributing to the thrust of economic development into the latter part of the twentieth century. In 1977, about $38 billion was spent on advertising by America's corporations,

most of it involving some form of pictorial representation. Of that sum, a significant amount came from the fashion industry —the makers of clothes, cosmetics, and other beauty products. But the numbers alone don't begin to explain the significance of fashion photography, which holds a special, one might almost say, privileged place in the hierarchy and history of advertising and photography. If the basic idea of advertising is to create the promise of a more attractive life, then fashion photography epitomizes that idea.

Fashion Photography History

Indeed, fashion photography has been associated with privilege since its beginnings in the early part of this century, and its first real flourishing in the 1920s. Not only was it associated with the life-style and manners of the upper classes and high society, it was and still is the one area of commercial photography in which many of this century's great pure photographers have

worked, Edward Steichen and Man Ray to Richard Avedon and Irving Penn.

The beginnings of fashion photography were modest. Until the 1890s, drawing was the medium employed for portraying the latest fashions in magazines. Then, photographs began to make a hesitant appearance. Into the second decade of the present century, they usually took the form of very simple and straightforward shots of individuals or groups of people. It was not until the 1920s that fashion photography began to develop in full swing, coinciding with the first realizations of the power and possibilities of advertising through the media.

It was the editorial side, the magazines themselves, that gave the initial backing to the new field. Condé Nast, the founder of *Vogue* magazine, was

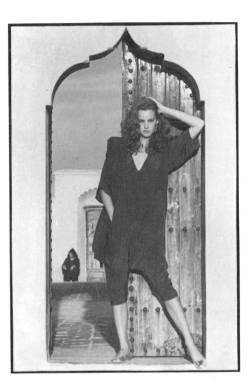

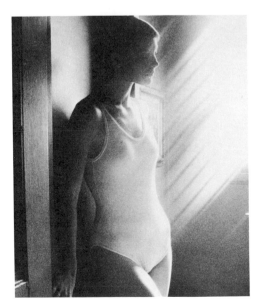

The essential skill of a good fashion photographer is the ability to create photographs with an attractive feeling, ambiance, or mood. In the top photograph, a feeling of exoticism and mystery is created by the North African locale, while in the lower photograph the simple ballet motif is enhanced by the use of light and grain.

The influence of fashion is increasingly prevalent in other forms of commercial photography. The way in which these models are dressed sets the scene for the product that is being advertised.

particularly instrumental in establishing a more imaginative approach to photographing fashion when, in 1913, she hired for that purpose the flamboyant amateur photographer Baron Gayne de Mayer, who is now generally recognized as the father of fashion photography. De Mayer's connections in high society and his penchant for a rarefied, romantic elegance made this first full expression of photographing fashions into a highly stylized genre. His models were posed in a way reminiscent of the nineteenth-century stage and early movies, with one hand on hip and head tossed back carelessly. The settings, when he used them, were richly elaborate and the lighting misty and atmospheric. He depicted a land of the wealthy and glamorous seen through a fairy-tale haze, unapproachable and yet desirable and available to the imagination; the perfect vehicle for creating covetousness in the magazine public.

The other great pioneer, Edward Steichen, who began to photograph fashions about the same time as de Mayer, in 1911, had an even more profound effect on the direction of the profession, particularly after he became a *Vogue* photographer in 1923. Steichen largely abandoned the theatrical poses and settings of de Mayer in favor of clear, descriptive lighting, clean lines, stronger compositions, and more unusual, sometimes slightly bizarre, settings. It was his influence that was felt most strongly throughout the twenties and thirties in the work of George Hoyningen-Huene, Cecil Beaton, Horst, and the many others who were then entering the rapidly expanding profession. The ideal now became the classic look of ancient Greece and Rome, apparent in Huene's work, with classical statuary used as props and its architecture as settings. Models were posed and related to their surroundings in the way that would bring out the purest outline and most serene expression.

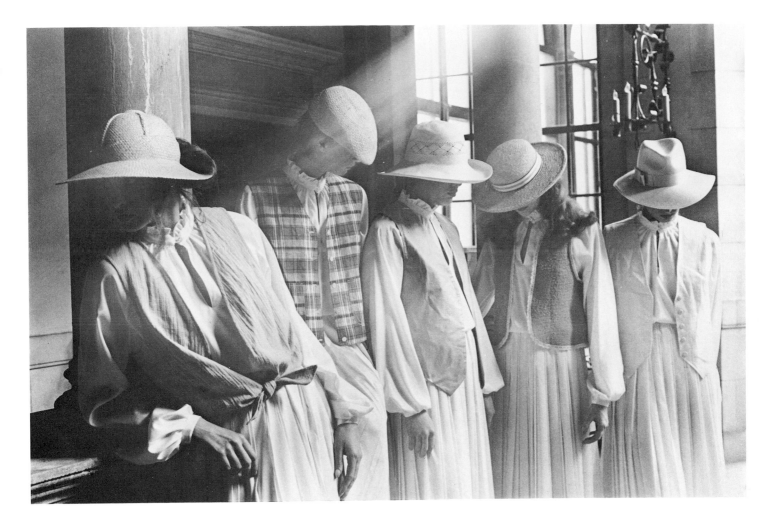

But gradually, during the 1930s, fashion photography turned toward a more natural and modern sensibility. Martin Munkacsi, a Hungarian-born news photographer, was a startling innovator of the time, introducing action pictures with models in outdoor settings, playing tennis, walking on the beach, or, in his most dramatic photos, perched in precarious poses atop buildings. He democratized fashion photography by bringing it out of the hothouse of the studio with its elegant interior, into the real, active world, while maintaining a highly theatrical sense of moment. Horst, on the other hand, began to explore an inner world, borrowing a page from the surrealists in art, using odd juxtapositions of different scales and subtly transforming figures and forms to endow them with an ambiguously suggestive meaning, sometimes sexual in nature.

In the forties and fifties, such photographers as Toni Frissell and Louise Dahl-Wolfe took still another direction. Up until then, women had always been the focus of fashion photography, but as the objects of

Mood and design are important elements of the advertising fashion which is appearing more and more on the pages of fashion magazines. (Bloomingdales. Art Director: Michele Bontempo.)

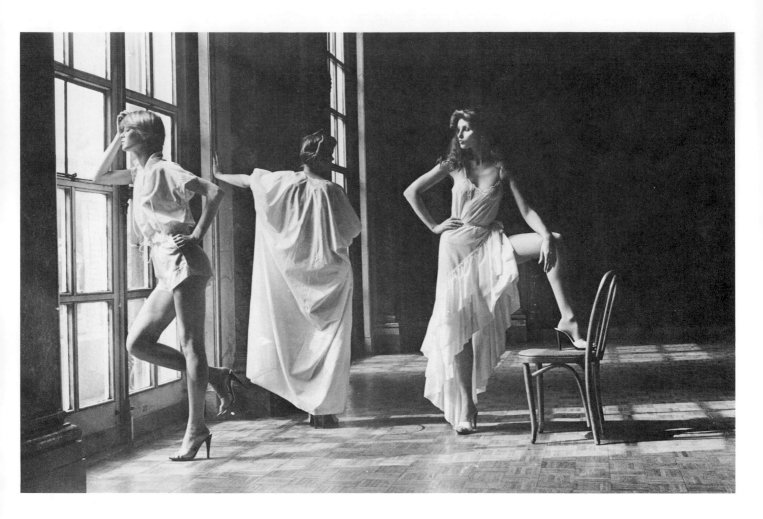

transcendent beauty and desire. In the work of Frissell and Dahl-Wolfe, perhaps because they themselves were women, the look of women took on a new kind of independence and self-sufficiency— they were portrayed not as mere objects, but as strong, clearsighted figures seen in natural settings.

After World War II, two photographers emerged to dominate the fashion field into the 1960s: Irving Penn and Richard Avedon. Both were essentially studio photographers in the old tradition, but they also projected a cool, clean,

thoroughly modern image that broke with the old-fashioned pictorial conventions, which relied heavily on painting. While each piece of their work is carefully controlled and meticulously planned, there is always the implication in it of freedom, that anything is possible, and that the model or subject can be made to appear anyway the photographer wants. This, coupled with the

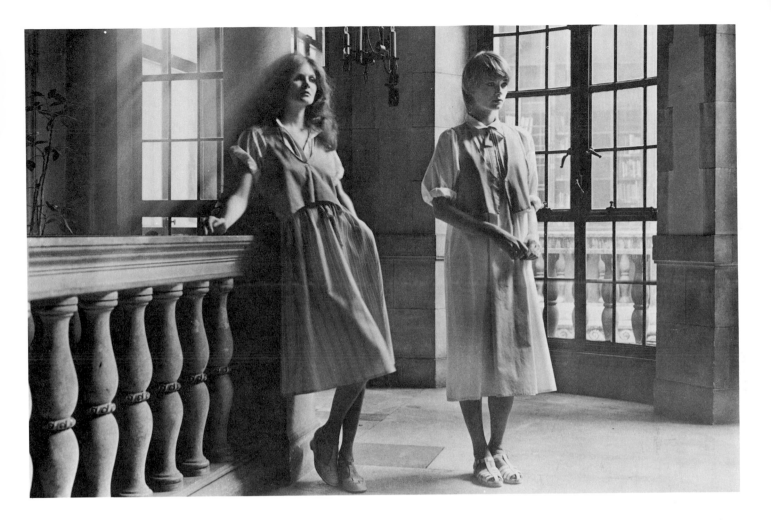

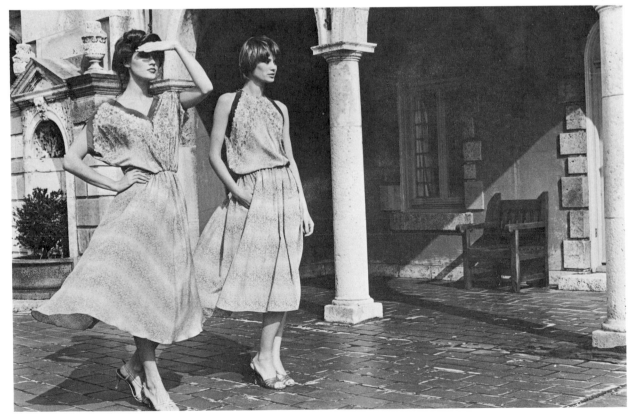

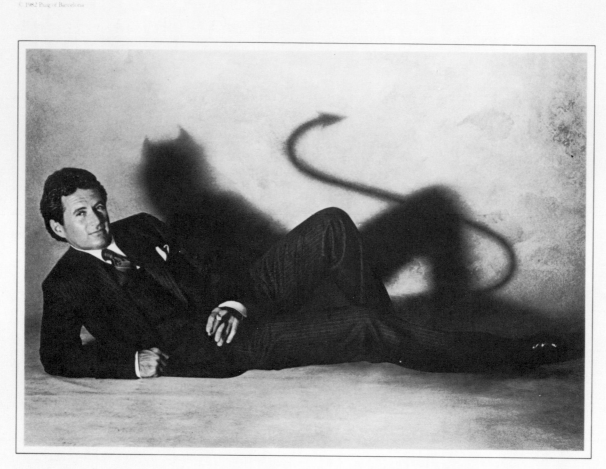

Introducing Quorum. A cologne for the other man lurking inside you.

Eau de toilette,
spray cologne,
after shave.

Often fashion photographers are used by cosmetic and perfume manufacturers in order to visually communicate the message which will help sell their product. Cover the image in this ad for Quorum mens cologne to see how inadequate the caption would be without the photograph. The eye-catching tail and horns were added by a retoucher.

increasing sophistication of cameras and equipment, a greater interest in color photography, and the cultural upheavals of the sixties, opened up vast new possibilities for fashion photography that have continued to develop into the seventies.

The photographer also developed a new image, epitomized in Antonioni's well-known movie, *Blow Up*, as a cool, fast-moving, and technically proficient observer who is completely involved in the quickly changing modes of the day, both in his art and his life-style. He is no longer a denizen of the remote world of high society and the country club, but, rather has become part of the popular culture that dominated the sixties: mini-skirts, long hair, rock music, Pop art, political involvement,

and sexual freedom. The photographer and his work have descended from the rarefied heights of an unruffled, genteel milieu and become subject to a much broader range of social and aesthetic forces. He has also gained recognition as a force, as one who affects and changes how we see not only fashions but the rest of the world around us.

Fashion photography is still a world of glamour populated by beautiful women and men, and, to a certain extent, a world of forbidden games. But, the gates have been opened for a much greater variety of expression, from idylls of the idle rich to the funky life of the streets, from scenes of domestic life to the elegance of high-style fashion, from the ordinary to the bizarre, from realism to abstraction. There has also been a growing awareness, since the sixties, that photography is a reflection of ourselves, of our daily lives as well as our fantasies, of our moods and our involvement with life on every level.

In the 1970s and 1980s, while there has been a move toward a more compelling realism and an even greater use of color, fashion photography has also become self-conscious of itself as art and of its history. Many contemporary photographers are turning to the masters of the past, drawing on the dramatic lighting effects, elegant posing, and compelling images of the early pioneers. At the same time, they are evoking the sense of mystery and intrigue that was part of fashion photography in an era when the equipment was much less sophisticated and the pictorial possibilities more static. The tendency in the more adventurous professionals is toward a purer, more offhand and unfinished mode of expression, reflecting the sense of ambiguity and intrigue that seems to capture the mood of

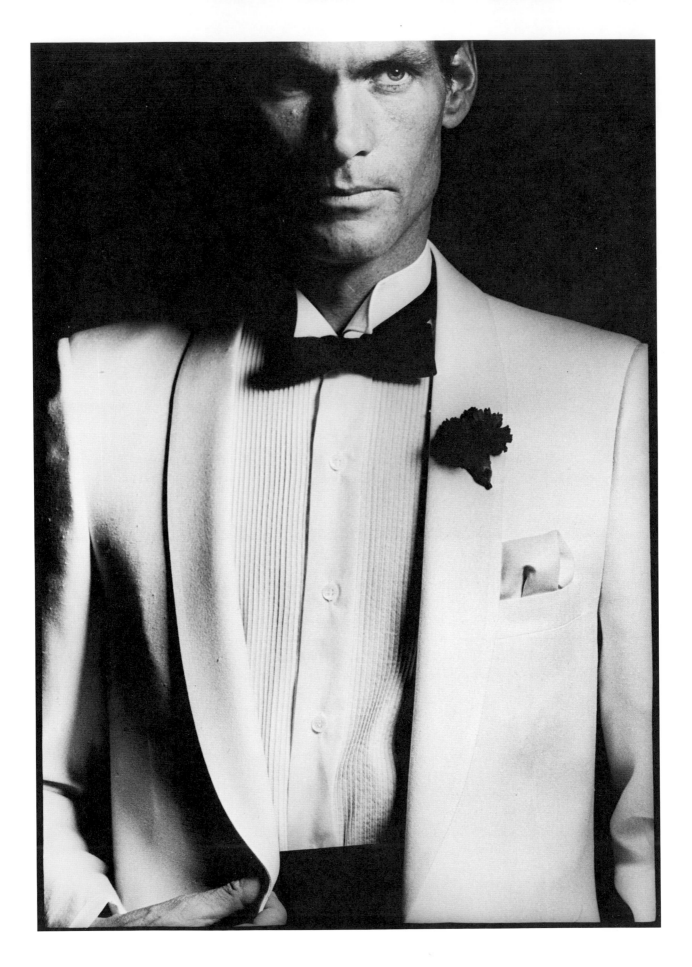

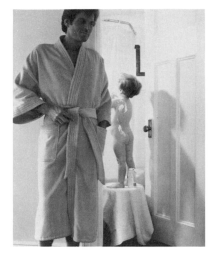

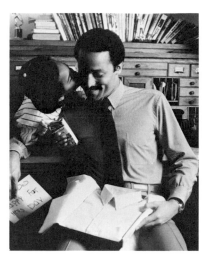

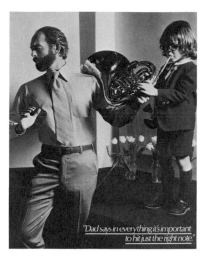

"Dad says in everything it's important to hit just the right note."

the times. In this and other ways, fashion photography has approached the caliber of work being done by contemporary artists and art photographers. Indeed, there has been a far greater recognition of fashion photography, along with photography in general, as an art form in itself, and today the work of a number of the most prominent fashion photographers, past and present, are exhibited in museums and private galleries. It appears certain that the strong identification with art and its own history will be an important part of the future of fashion photography.

While retaining its playfulness and sense of perspective about itself, in many ways fashion photography is more vital and consequential than ever before. It is probably the only area of commercial photography where one can exploit the full range of human expressions and moods. The awareness of photography's sensitivity and the purely visual possibilities of the medium have become driving forces, not only in the work of photographers themselves, but also in

the motivation of many art directors and fashion professionals. There is a great deal of mundane work to be done, both for practical reasons and because many magazines and advertisers wish to maintain a certain image. Straightforward shots of a model in a dress, a bathing suit, or sportswear are still the staple of the business, and clients still complain about imaginative photographers distorting or taking liberties with their products. But at its core, fashion photography is still a matter of fantasy, art, and imagination, which thrives on the ability of its practitioners to constantly come up with new, exciting, and creative images.

The photographs above were part of an assignment for a Saks Fifth Avenue catalog for Father's Day. By using a 35mm camera, I had greater flexibility of movement and expression than I would have had with a large-format camera, and that flexibility helped me capture a sense of emotion between father and son. (Saks Fifth Avenue. Art Director: Leonard Restivo.) The photograph on the facing page, for Bill Blass Menswear, was also taken with a 35mm camera. It was lit by a single strobe head in a soft box, and the light reading was taken directly at the light source in order for the photograph to fall off into black on the side opposite the light. (Courtesy of Domsky & Simon Advertising.)

Editorial Fashion vs. Advertising Fashion

In fashion photography, the photographer is doing basically two things: promoting a product, whether it be a perfume, an evening gown, or a pair of dungarees, in all its radiant, elegant, or useful splendor; and capturing a world and a feeling that is ephemeral. This is the meaning and the nature of fashion: constantly changing styles that reflect new situations, new ideas, new ambiences, and new attitudes towards everything that surrounds us. The photographer must not only be intensely aware of the subject he is shooting—the qualities of luxurious softness in a fabric or the brilliant redness in a lipstick—but also of the context in which it exists—the elements of style, pose, and even drama, that combine to make up that moment in time. Both elements are essential to success in the field.

Most fashion photographers are engaged in basically two aspects of the trade—editorial and advertising fashion—each of which stresses one element over the other. In editorial fashion, the photographer is working di-

rectly for the magazine, for example, a fashion, men's, women's, or general consumer publication, and is therefore usually concerned with the mood, feeling, and drama that will fit in with the image of the magazine, rather than with the particular objects being shown. In advertising fashion, where he is working for a manufacturer or an advertising agency, the product they represent takes precedence, and it is the photographer's job to present that product in a way that will best promote it.

Advertising fashion is not always primarily merchandise-conscious; the reverse is true here. The visual impact of this ad brings more attention to this advertisement, than one that is completely merchandise-oriented would. (Geoffrey Beene, Vogue *magazine. Art Director: Walter Russell. Copywriter: Jayne Ingram.)*

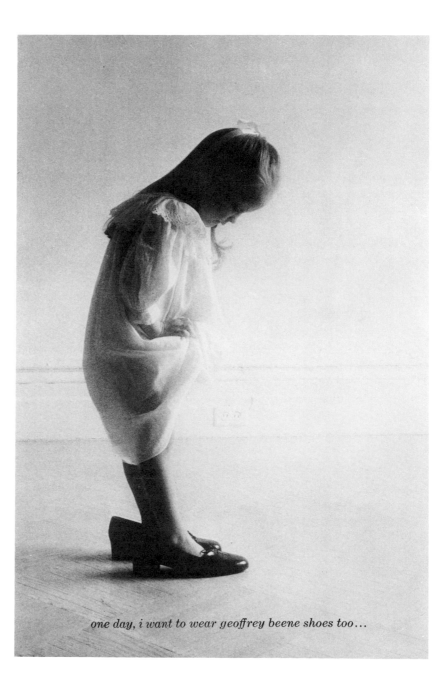

one day, i want to wear geoffrey beene shoes too...

Many times, a certain attitude in the models, as in the decadence projected here, will help sell high-fashion garments.

Editorial Fashion

By editorial fashion we mean photography done for the editorial as opposed to the advertising pages of a magazine or newspaper; however, the ingredients for both are essentially the same: the photographer works with models, on location, or in the studio; he is responsible for achieving a certain mood; and his subject is a fashion product or group of products. But, in editorial fashion photography, he is responsible not to the maker of the product, but to the style and outlook of the magazine; the idea being to create the kind of picture layout that will have the greatest appeal to that magazine's audience, while still calling attention to the qualities and advantages of the products illustrated. This affords the photographer greater freedom in originating the concept to be followed, choosing models and locations, creating the mood, and, in general, controlling the entire shooting. And, while more and more advertising agencies and manufacturers are beginning to recognize that photography has come into its own as an art form that can be used as a form of visual enjoyment, and are, therefore, giving the photographer greater leeway, it is in the editorial field that the greatest freedom is to be found.

Fashion Magazines. Of course, there are as many editorial styles as there are magazines, and the photographer may have a tremendous range of situations to which to adapt himself.

All of these publications are interested in the latest fashions, but their approaches vary considerably. Magazines devoted entirely to fashion, since they appeal to a fashion-conscious audience, concentrate on high fashion. They include such publications as *Vogue*, *Harper's Bazaar*, and *Gentlemen's Quarterly* in the United States; *French Vogue* and *Votre Beauté* in France; *L'Uomo Vogue* in Italy; and *Harpers and Queens* in England. They evoke the elegant couturiers of Europe and tend to the most exotic, even outlandish, settings and the most experimental photography. General consumer and women's magazines with fashion sections, including *Ladies' Home Journal*, *McCall's*, *Redbook*, *Elle*, *Marie Claire*, and *Good Housekeeping*, are at times elegant but lean to a more everyday, down-to-earth approach, with a look that might appeal more to the middle-American or European housewife or career woman.

The format of the men's magazines, for instance, *Playboy*, *Penthouse*, and *Esquire*, allows them the freedom to use a narrative approach to tell a story, sometimes with erotic overtones, in which the fashion products become accessories. Some specialized magazines, for example, *Bride* or *Modern Bride*, have a "happy ending" style in which fashions are presented in a lyrical, unspoiled way.

The traditionally conservative magazines are beginning to show a willingness toward more flexibility, to liven their pages with new ideas—something out of the ordinary. I recently did a spread for *Modern Bride* that pictured the models in the latest fashions and in a very beautiful setting. At the end of the layout are several shots of a model showing, demurely but somewhat coquettishly, the lingerie that can be worn with these fashions. This is the kind of innovation that was unheard of ten years ago, but which is now entering into the thinking of magazine art directors and editors.

The wide divergence of these two approaches to editorial fashion does not limit any one photographer to one or the other of them. Rather, many of today's photographers have developed the versatility to encompass a variety of approaches and are able to move with ease from a dramatically lighted, provocative narrative sequence devoted to sophisticated evening wear, to a placid, evenly lighted series on the innocence of youthful fashions. In fact, there have been several occasions when an art director has asked me to do a particular kind of job based on his knowledge of my work in quite a different vein.

To sell a bridal gown without distracting from the product, and yet enhancing the appeal of the ad, was accomplished by bringing into the photograph a little girl, which changed the entire look of the picture. (©Modern Bride magazine. Art Director: Sunday Hendrickson.)

Example: I was assigned to do a group of pictures for *Ladies' Home Journal*. I was to follow, in a calm and professional way, the daily routine of several women and the clothes they wore at different times of the day—at home, at the office, at lunch, in the evening. What interested the art director of that magazine in my work, however, was a starkly contrasting, darkly brooding, rather evocative narrative layout I had done for *Viva*, titled "The Godmother," not strictly a fashion layout at all, but one that suggested a range of possibilities to someone looking for a more dramatic angle in a fashion layout.

Part of the enjoyment, then, of fashion photography, particularly on the editorial side, is the myriad situations one encounters in various assignments and the opportunity to work out solutions that may

be poles apart. It is therefore important for a photographer to develop the capability to deal with almost any kind of assignment, and to learn from one situation what to apply to another.

In most cases involving editorial work, the photographer deals with the art director and one or more of the fashion editors on the magazine. There are some who know exactly what they want and will give detailed instructions on how to accomplish it; this happens frequently in advertising fashion. But quite often there is a meeting of minds. The editors may have a general idea of what they are after, say, spring fashions in Paris, what to wear on a boat, or

men's fashions for women, and may consult with the photographer on how to achieve it. As confidence in and rapport with the photographer grow with experience, the job may be left increasingly to him, or he may, in fact, originate an idea just as a writer might for a story. This, of course, is the ideal situation for any photographer, as it enables him to be as creative as he wants to be, to fully express his ideas about mood, lighting, composition, and fashion itself, and to show what he can really do in a way that may arouse the interest of other art directors or advertising agencies.

Credit Lines. It is on the editorial pages that the reputations of most fashion photographers are made, because it is there that his work can be seen to the best advantage. It is there that the art directors of magazines and ad agencies look, not only for photographic talent, but for ideas and ways of doing things that might suit their own needs. The magazines are a bible for those who hire photographers, in that they reveal what is going on in the field and who is doing what. Important, too, is the fact that the photographer usually gets a credit line for this kind of work—something that rarely happens in advertising fashion. There is no way to estimate the value of the credit line, but by placing the photographer's name in a prominent spot more than makes up for the greater amount of money he gets for advertising fashion. Because fashion is a constantly changing field, this is as important for the well-established photographer who wishes to keep his name in the forefront as it is for the beginner who is just starting to get his name circulating. Any type of credit is important,

whether it is for a single picture in a prestigious magazine or a ten-page layout, but, of course, the ideal is to receive credit not only for the photography but also for the conception and direction of the story. The fact that a photographer has been given carte blanche by an art director to create his own image naturally carries a great deal of weight in the field and contributes to both his reputation and his bargaining power.

To be left completely to one's own devices has a special meaning and can have special results. On one assignment for *Viva*, the only direction I was given was to use resort clothes. Because of the confidence that had developed between the art director and myself over several jobs, I was given full responsibility from beginning to end, from concept to the finished chromes. Not only was it satisfying to create something that was totally my own, but it also resulted in a credit line that read: "Produced and photographed by Robert Farber"—an unselfish

recognition by the art director that was both unexpected and tremendously valuable. (That assignment is illustrated in Chapter Four.)

Pay Rates. Fees for editorial fashion are established on a page rate and vary depending on the magazine's prestige, circulation, amount of advertising revenue, and so forth. National and international magazines, such as *Vogue*, *Playboy*, *Gentlemen's Quarterly*, and *Ladies' Home Journal*, pay anywhere from $250 to $600 per page, whether there is one or five pictures on it. Some magazines pay as low as $150 per page, using their prestige to justify lower fees. But it is usually worth it to the photographer if the lack of money is compensated for by a credit line and exposure.

Financial compensation for editorial work can also be inconsistent and unpredictable. For instance, a shooting in color will usually return more than one in black-and-white, despite the fact that black-and-white involves more work

and expense in making contact sheets, selecting the pictures, and printing the final choices. With color, the final product is ready as soon as the film is developed. But because color has more value to magazines, they are willing to spend more for it.

The page-rate system can also produce some surprises sometimes; when a story originally planned for several pages is reduced in the final layout to one or two pages. In this case, the photographer is paid only for the pages published. On the other hand, when a layout runs to 10, 15, or even 20 pages, the financial reward can be substantial. And there are ways to get around the tighter magazine budgets, simply because many models, stylists, and other people involved in a shooting are willing, like the photographer himself, to make less money in favor of credit and exposure. In any case, few photographers will turn down a job because it doesn't pay their usual rates, if they have the opportunity to prove themselves and build a reputation.

Because the magazines cover the fashion scene nationally and internationally, one of the fringe benefits of editorial shooting is that it can involve travel throughout the United States, Europe, and other parts of the world. Advertising agencies and manufacturers sometimes use foreign locales for their campaigns, but it is more common for a magazine to put a group of editors, models, and a photographer on a plane to Rome, for example, for a story on the latest fall fashions. One reason for this is that it enhances the image of the magazine; whereas the manufacturer, for whom the product is uppermost, does not benefit as much from an exotic setting. Another reason is that the magazine is often able to obtain free plane fare and accommodations for its staff in exchange for credit to the airlines and hotels, an arrangement that is more difficult for the manufacturer to make. Whatever the reasons, it is a great boon to the photographer, not only because of the excitement of travel itself, but also because it gives him the chance to use settings that might not otherwise be available to him and, thus, to broaden the scope of his own work.

This photograph, taken in North Africa for Saks Fifth Avenue, was lit only by direct sunlight. In this situation, we went where the people were, and positioned the model in relation to them, instead of hiring background subjects and positioning them in relation to the model, as is usually the case. This picture also shows how the attitude projected by a good, professional model adds the final touch that makes the picture. (Saks Fifth Avenue. Art Director: Gary Lowe.)

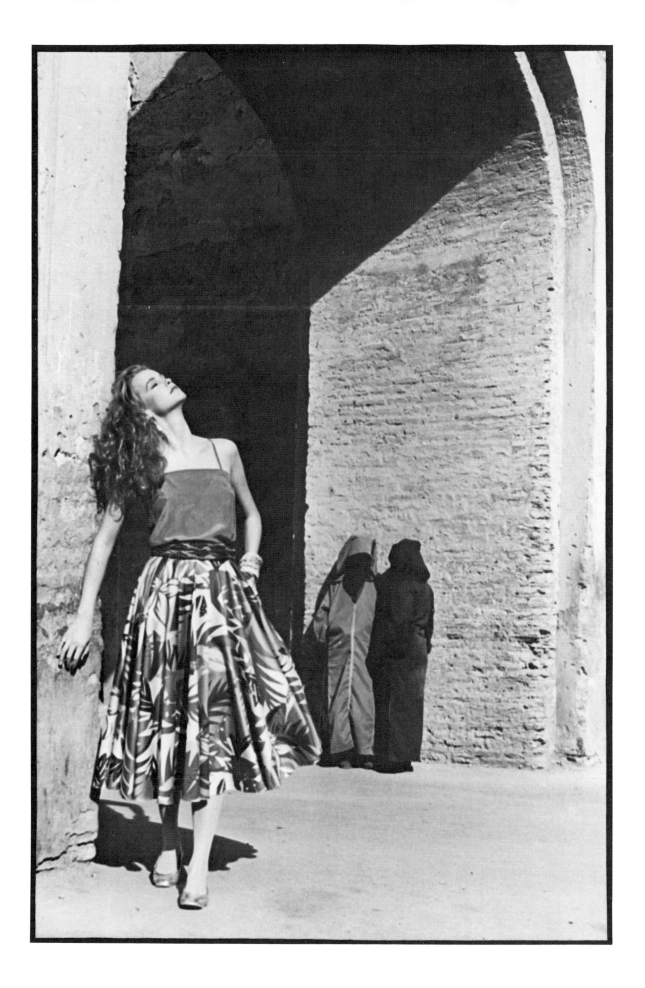

Advertising Fashion

Although the freewheeling attitudes of editorial photography have extended somewhat into advertising photography, in many respects the latter represents another world. Everything available to the photographer—the choice of setting and model, lighting, mood, composition—is concentrated on presenting the product, hence the shooting is subject to the direction of the client to a greater degree than editorial photography. Advertising fashion is a more conservative field; it does not have the latitude for the kind of experimental photography that can be seen in the pages of many European and some American fashion magazines. This does not mean that the photographer is completely straightjacketed by the requirements of the client. It sometimes happens that the requirements of the medium can turn a photographer into a technician who is simply carrying out a preconceived plan, yet, more often, there is room for him to create some of his own effects, to express his own style, and this can be a tremendous challenge in accommodating one's own ideas with the client's demands.

By turning the pages of a fashion magazine, one can immediately see a categorical difference between the editorial and advertising layouts. In the latter, not only is the name of the company printed on the page, but the elaboration of the setting and the creation of a mood are downplayed in order to focus on the product. The pose and features of the model

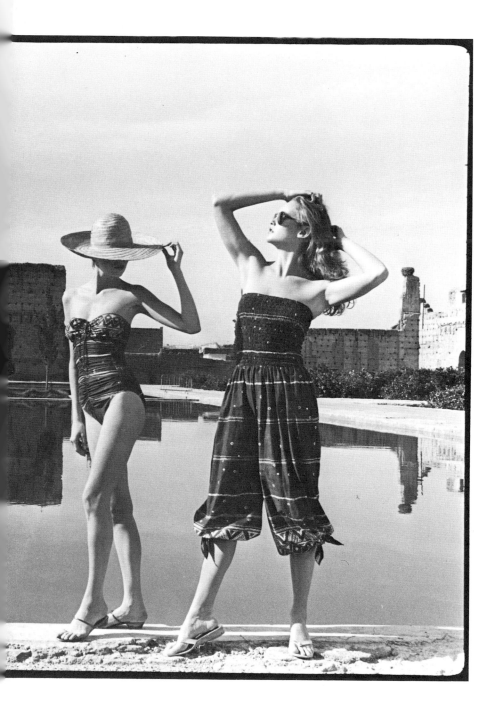

While an exotic location can add a certain ambiance and flavor to a fashion photograph, it is often important not to let the location overpower the clothes being shown, or the product being sold. It is also imperative that the photographer know how the photograph will finally be used in reproduction, and if it will be spread across two pages so the photographer can plan the image accordingly. (Saks Fifth Avenue. Art Director: Gary Lowe.)

tant and anything that is too strong or attractive in itself, be it mood or ambience, might detract from the intended center of interest.

The nature of advertising photography is likely to change over the next few years, as agencies and manufacturers continue to discover the power of the photographic image in creating vicarious situations that may have more appeal than the careful detailing of a sport jacket or pair of pantyhose.

Advertising fashion is a multifarious field, the biggest accounts being the large national and international garment manufacturers and cosmetic firms. Their ads appear in a cross-section of national magazines that reach millions of people, and their appeal is usually the broadest. Those same companies may develop ads which have a more sophisticated or stylized air, especially for the fashion magazines. Some may want to create a certain setting in which the product is shown to the

may be less expressive, often to the point of stiffness. This is true particularly of men's fashion ads, where the traditional idea of presenting the suit, shirt, or even sportswear without a wrinkle or indication of how the garment moves still prevails. Settings, locations, and props are also less unusual in advertising layouts. They are determined by the ad agency to fulfill the standard expectations of the people to whom the ad is addressed, again because it is the product that is impor-

greatest advantage, others may want to be associated with a certain mood, represented by a sunset or a windswept beach. Cosmetic and hair products focus the camera on the head and face; garment manufacturers may want to bring out every detail of texture and stitching and will airbrush obsessively to achieve that effect. On the other hand, there are some national advertisers and some local department stores in New York that are attempting to use the photographer's skill to create aesthetically interesting and offbeat scenes that will in themselves evoke the potential buyer's attraction to a product.

Ad Agencies. Advertising fashion is usually done through an agency representing the client, although there are times when the photographer works directly with the client or his in-house agency. Most agencies have a creative director, art directors, and account executives, any or all of whom may be responsible for creating the idea for an ad or campaign, and, ultimately, the photographer must work with these individuals. The ins and outs of this relationship are discussed fully in Chapter Three, but suffice it to say that in most advertising fashion, the photographer is responsible, not for the concept, but for the execution of the concept. It is the nature of advertising campaigns that they cannot be left up to the photographer to do at the last minute, but must be planned well in advance with the full participation of the agency personnel and the full consent of the client. The photographer may be involved in some of this planning, but it is at the point of actual shooting that his viewpoint may enter in, concerning the way a scene is shot, lighting, and so forth. Although the photographer generally is not the architect of an ad, as the last link in a process that often involves an enormous input of thought, energy, and money, he bears a great responsibility.

Pay Rates. And the financial rewards for advertising photography are great also, usually far in excess of the amount paid for comparable editorial work. Just as advertising provides the major revenues for the magazines, advertising fashion is the bread and butter of the fashion photographer. Fees are usually determined by the size of the budget and may go as high as $3,000 for a single ad, but are more often in the range of $1,500 to $2,000. If the photographer is required to establish the fee, it is usually done on the basis of a day rate figured against the amount of time calculated for a particular job. There are, however, many variables. If it is a major ad for a big national company, the photographer may charge more than a normal day rate. If the assignment involves more than one ad, that can be shot in a single day, the fee is still based on the ad, not on the amount of time spent. Other considerations that affect fees include: whether the ad is in color or black-and-white (color pays more); where the ad will appear—in a national or regional, trade or consumer magazine; whether it is for a major campaign or a single ad.

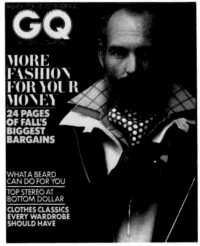

The cover photography of a magazine must be a strong image, since it is the packaging that must help to sell the product. Although it has certain creative restrictions, a cover is the most prestigious credit for a photographer, as well as probably the most challenging of assignments. (GQ. Art Director: Harry Coulianos.)

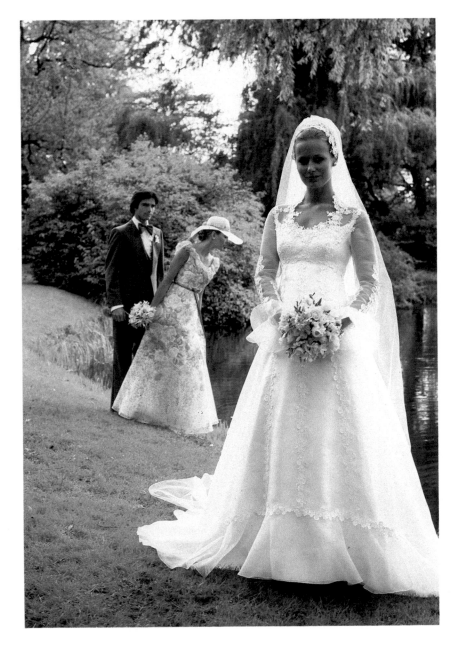

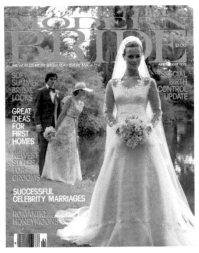

The cover must capture the editorial feeling of the magazine, appeal to its potential readership, be photographed within the same monthly format, and, at the same time, convey some of the photographer's creativeness and style, without overpowering that of the magazine. This cover is an example of instances where the art directors gave me more than usual freedom to add a little extra touch of my own and to slightly break away from the regular look of the magazines' covers. (© Ziff-Davis. Art Director: Sunday Hendrickson.)

These two photographs below were originally a test, but when the art director of Gentlemen's Quarterly saw my portfolio, this test led to the following assignment (center). (GQ. Art Director: Harry Coulianos.)

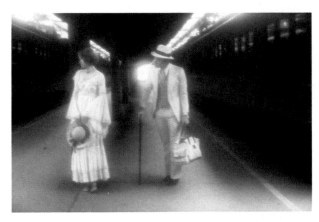

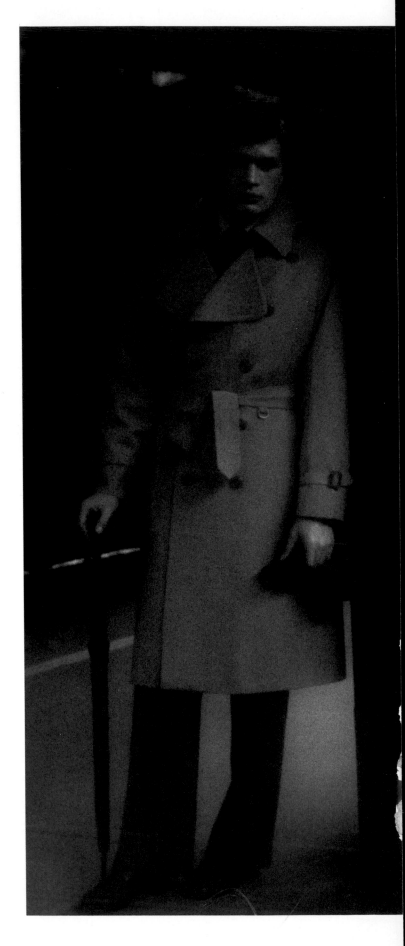

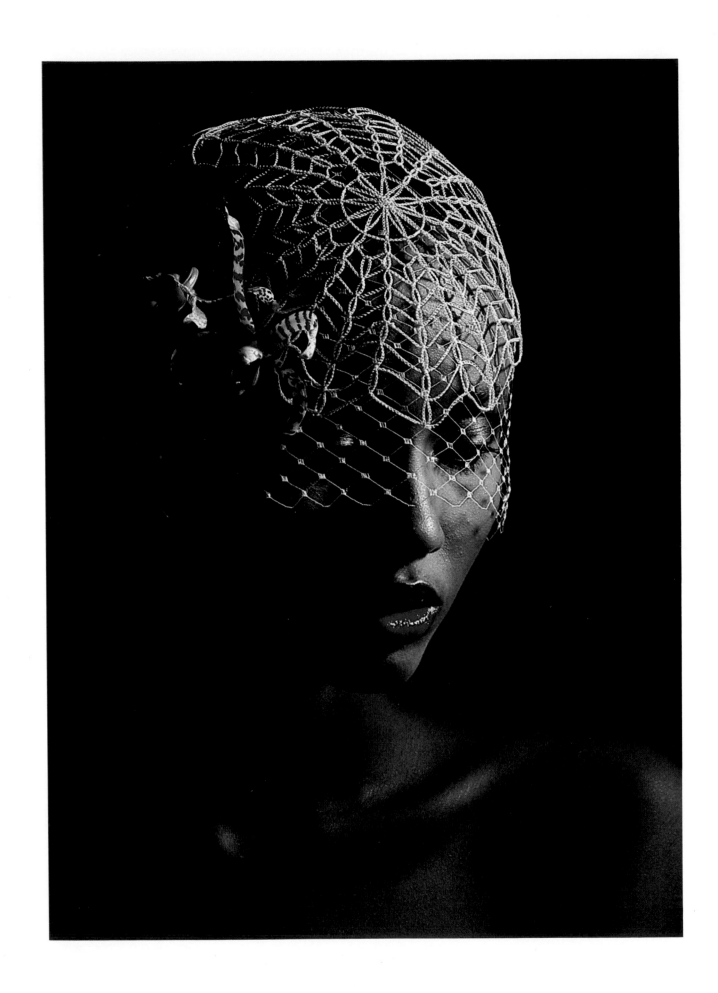

When putting your portfolio together, if you use the same type of lighting for all head shots, the only difference between one photo and the next will be the face itself. In these four pictures from my portfolio, I tried to achieve four totally different types of beauty pictures. (Left) A strobe used with direct light creates a harsh but dramatic effect. (Below) Natural window light, northern exposure, and a soft, directional light create a different effect. (Top right) Tungsten lighting with daylight film results in a warm, dramatic look. (Bottom right) Natural, direct sunlight softened by a filter results in still another look.

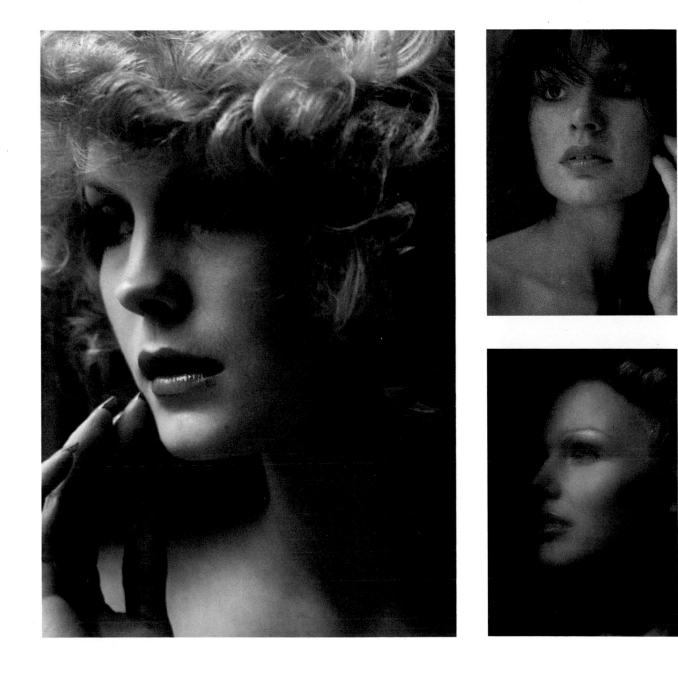

This is part of a fashion layout that was done in Paris for Esquire *magazine. In order to avoid typical French monuments, but still retain the flavor of Paris, we used only touches of its architecture and its back streets. Sometimes it is more effective to have a model standing next to a typical Parisian lamp post rather than in front of the Eiffel Tower. (*Esquire *magazine. Fashion Editor: Robert Liebler. Art Director: Michael Gross.)*

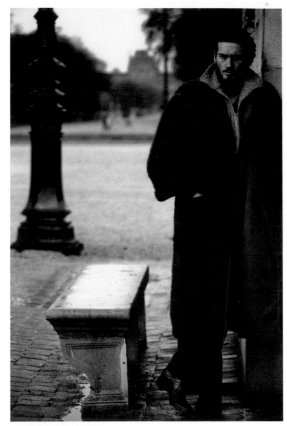

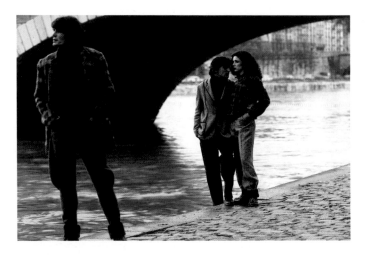

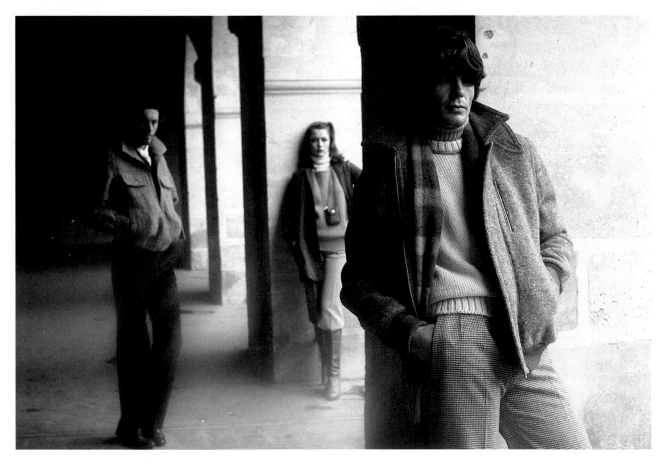

Advertising fashion has other economic advantages over its editorial counterpart. One is that the photographer knows exactly what he is getting for a specific job; his fee is not dependent on the number of pages used. It is also much easier to schedule the time required for shooting an ad, since it is a known quantity. In editorial shooting, there can be a great deal of improvization and therefore more time spent at lower rates.

Credit Lines. Credit lines are seldom given in advertising fashion. Usually they are considered to distract from the focus on the product, but there are some clients who want to be associated with the work of a particular photographer. Such a situation may give the photographer the option of throwing his normal rates out the window and negotiating his own contract. That rarely happens, but when it does, it represents a kind of pinnacle in advertising photography. It is the point at which the photographer's style becomes absolutely identified with a product and he, as a result, becomes indispensable to the client.

Striking a Balance in Fashion Photography

It is essential for the photographer to strike a balance between editorial and advertising fashion, to engage in both areas throughout his career. But, perhaps more important to his own well-being, is the attention he pays to photography itself. A typical career in photography starts as a hobby, but, in the crush of business and with a certain amount of success, photographers often forget what it was that attracted them in the first place, what they loved about photography as a hobby. When this happens, the photographer forgets about developing new ideas, about the things that originally stimulated him, and, in doing so, begins to limit his future. So, it is important to constantly think of new ideas and evolve old ones in order to maintain an approach that is always fresh and attractive to potential clients. If a photographer concentrates solely on the commercial side and forgets about his art, it will eventually hurt him commercially as well.

CHAPTER THREE

Dealing with Clients

From the time he is commissioned, until the completion of a job, the photographer is involved in a relationship with his client—whether it is an advertising agency or a magazine—that may amount to anything from constant surveillance to a completely hands-off attitude. There are those rare assignments in which the client plays an active role only at the beginning and the end, and the photographer has total freedom between the point of assignment and the final layouts. But, usually, the client is there at every stage of the work and is often involved in establishing the specific composition and look of the ad or layout; in choosing models and locations; in determining whether the shot will be vertical or horizontal, softly or sharply focused; and, of course, in selecting the photo to be used in making the final layouts.

In many ways, the relationship between photographer and client resembles that of artist and patron before the nineteenth century. In commissioning works of art, the patron was often motivated, not only by a desire for beauty,

but also by a wish to promote certain ideas, either religious or secular, as well as the glory of his own name. He hired the artist on the basis of style, talent, and fame, and the artist carried out the task, to a greater or lesser degree, according to the dictates of the patron, whose directives sometimes concerned such details as setting and the type of clothes to be worn. Patrons often involved themselves in the work, sometimes with salutary results and sometimes to the ultimate exasperation of the artist.

That exasperation is not unknown in fashion photography, but, like the artist and patron of old, in a majority of cases the photographer and

This ad is not the original concept as approved by the client. The layout I had to follow was entirely different. When shooting an assignment, a photographer must make sure to first satisfy the clients by shooting it their way, then satisfy himself by shooting it his way. If it turns out that the photographer's concept is preferred, the creative people with whom he works will have more respect for his talents, thus leading to greater creative freedom for future assignments. (Revlon/Grey Advertising. Creative Director: David Leddick. Art Director: David Davidian.)

Revlon: the name that should be on your lips.

Give your lips the wettest, richest, most beautiful look the world has to offer. Revlon lipstick. Juicy with moisturizers, gleaming with shine, lasting hour after hour. Revlon: famous for colour. Revlon: the name that should be on your lips...always.

Revlon
WORLD'S LEADING COLOUR AUTHORITY.

The photographer should not limit himself to only certain types of assignments. He must be able to adjust his style to conform with whatever image the client desires and make his clients aware of this versatility. Although this soft, romantic beauty shot is very different stylistically, from the hard, realistic picture on page 39, they both capture the same mood.

client are able to establish a working relationship that gets the work done without the tempestuousness that occasionally enlivens both the history of art and of fashion photography. The photographer must know that there are certain givens, that the client who has hired him has the initial and the ultimate say about what will and will not appear. It is, after all, his product that is being promoted in an ad, or his image that is being circulated in a magazine, so he naturally takes a great interest in how it is done. At the same time, the client must be aware, and usually is, of the photographer's talent, style, and suitability to the particular job and should allow him the creative freedom to accomplish it. It is in the client's best interest to make the right choice and, then, to make the most use of the talents for which he hired the photographer in the first place.

By the time they call in a photographer, most magazines and ad agencies have at least a pretty good idea of the broad outlines of what they want to do. How far they go in this planning depends on many fac-

tors. One that ultimately affects the photographer's work is the relationship between the ad agency and the client or company whose product is being advertised. Sometimes the agency does not have total freedom to plan an ad or campaign, particularly regarding major national efforts on which a lot of money is being spent. The ad concept may entail endless meetings, proposals, and counterproposals, involving executives up to the top echelons, until a comprehensive plan is arrived at and a final decision made. By the time the photographer gets into the act, the ad may be all but an accomplished fact. Decisions may already have been made concerning the models to be used, the clothes to be worn, the setting or predominant color, the kind of lighting and focus, the props, and so forth.

Moreover, the completed photograph itself will require final approval from the top.

A similar situation can occur with companies or magazines that have an established image and do not want to deviate from something that has been successful in the past. The photographer then must adjust his style to conform with that image. This happens particularly with packaging, whether it be a box containing hair coloring, or undergarments, or even a cover for a magazine, which must be immediately recognizable to the customer. However, agencies and magazines are constantly on the lookout for new ways of doing things, for fresh ideas, and for photographers who will fit into the overall fashion of the times.

At the beginning of any assignment, there must be total understanding between the photographer and the client about the nature of the assignment. The discussions preceding the actual shooting can range from a few minutes over the phone with the creative director or art director to an elaborate planning of every detail. How elaborate these discussions are depends on a combination of factors: practical, organizational, political, aesthetic, and personal.

Planning the Assignment

Practical factors refer to the planning made necessary by the complexity of the job itself. Obviously, if the shooting involves only a single model against a plain background, or a head shot, there needn't be much discussion, although even the simplest job can be affected by any number of conditions. The client, for instance, may want to use a particular model or at least a particular kind of model—a woman with an all-American look, or a man with a fatherly look. He may specify that the

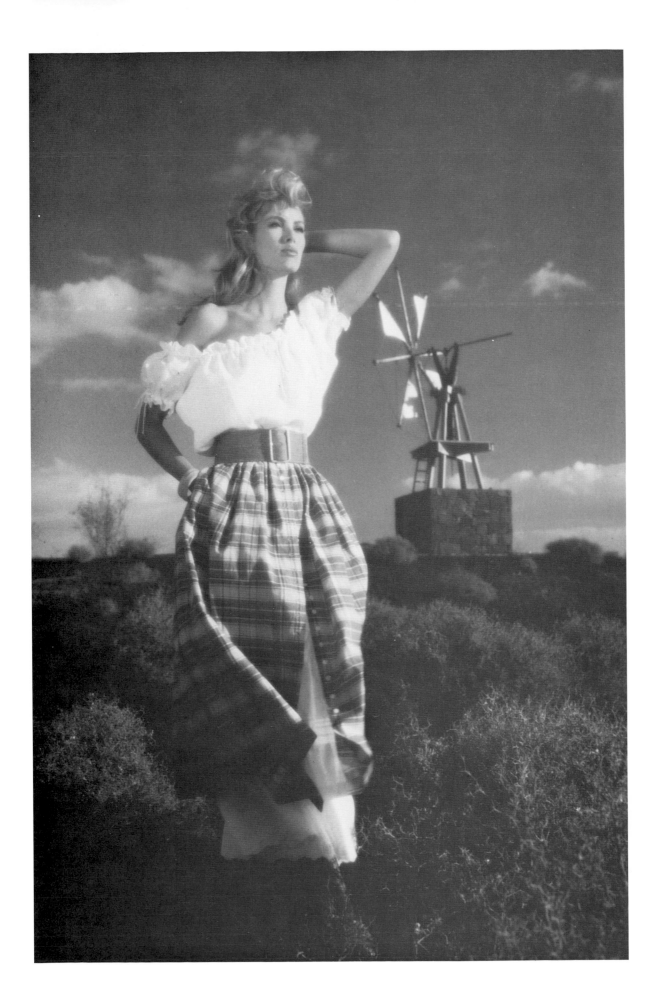

mood be frivolous or mysterious; that the focus be soft and romantic or hard and realistic; that the model be standing, sitting, running or jumping. He may go to the extent of specifying which type of film to use. There is also the question of layout: whether the image should be horizontal or vertical; what kind of space it is intended to fill; how much copy will accompany the picture and where it will be placed. Usually, all these considerations, after a general discussion, are left to the photographer, but it is essential for him to know how far he can go in using his own imagination and to what extent he must adhere to the client's requirements.

When the job is more complicated, it may involve more planning. But here, again, some art directors will set down fewer conditions for a very elaborate shooting—one involving several models, an unusual setting, hordes of props, and an imaginative scenario—than others will for a very simple one. This was the case with the *Viva* assignment referred to in Chapter Two. The entire conception and shooting was left to me, and the magazine worked around the photographs I gave them to create an editorial sequence with headlines, captions, and so forth.

Although this sort of freewheeling approach occurs more often in editorial than in advertising fashion, art directors in both areas usually play a more active role in expressing their specific requirements to the photographer. An art director for a fur-coat ad or editorial photo may simply outline a situation in which the fur-clad model is shown in an elegant nighttime setting with a male escort. He may add that she

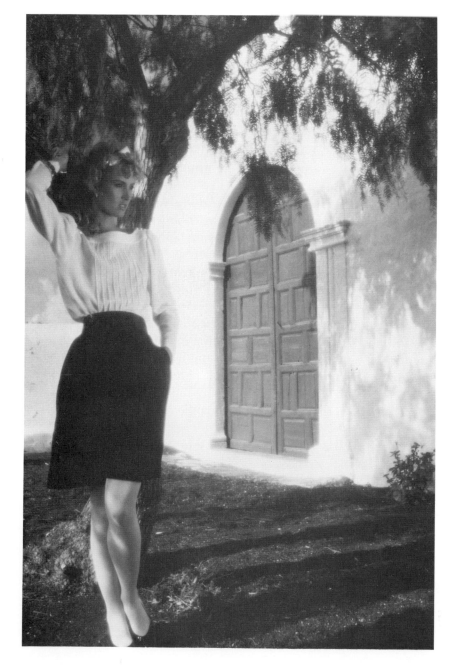

should be stepping out of an expensive car or entering a nightclub. He may then indicate that the advertising copy or caption will appear in the lower left-hand part of the picture and space must be left for it, and that the gutter of the magazine will be on the right side, so the picture should be shot to avoid any interference of the image by the gutter, particularly if the picture runs across two pages. Sometimes he will provide a sketch to make sure the photographer knows the exact placement for everything.

There are, however, art directors or specific jobs that require something beyond a rough sketch and verbal communication to ensure that the final ad or layout accords with the conception as planned. In

such instances, the photographer encounters the comprehensive layout, or "comp," a more detailed drawing or set of drawings that outline how an ad or editorial spread is meant to look. In some cases, the comp serves simply as a guide to the photographer, to show him how the pictures are to be laid out, their shape, caption material, and the like. They can, however, be much more precise when the art director is intent that the photographer produce the exact image he has worked out with his editorial staff, if it is a magazine, or with his client, if it is an ad. The comprehensive layout will then take on the characteristics of a finished illustration and will show the poses, the setting, the props, even the mood; in other words, the exact treatment of the subject as it is to be captured on film. The photographer is then faced with a situation that is not of his own making, one in which his creative input is curtailed, and he is expected to follow instructions as a professional technician.

Doing It Your Way. There is a very simple solution to this dilemma, and it was suggested to me by one of the most respected ad agency creative directors in the field. We worked together on my first assignment for one of the major cosmetic firms and at the end of our preliminary discussion of the ad, before the actual shooting, he advised me to do the photo exactly as I had been instructed in the comp and then to "do it my way." In other words, a photographer can both satisfy the needs of the client and assert his own creative intelligence by doing the assignment both ways. It is a procedure that I have followed throughout my career, whenever time and conditions have permitted, and, in surprisingly many instances, the client has chosen my way of setting up the shot over his preconceived notion. Most art directors appreciate having the choice and working with a photographer who is actively engaged in creating the image and in adapting the original conception to the actual circumstances of a shooting session. It also gives the di-

rector more confidence in the understanding and ability of the photographer for future assignments.

Knowing the Organization

The kind of relationship a photographer has with a client is also affected by the nature of the organization and the way it operates internally. Although the photographer is accountable to only one person, usually the art director or creative director in charge of the project, it is helpful to know his standing and the status of others who might be called in for advice and counsel on any given job.

Advertising agencies may have several levels of executives involved with creating an ad or a campaign. The creative director generally has overall responsibility for the ads that come out of his agency, as well as the final and sometimes initial say in how each campaign is approached. He often hires and instructs the photographer, although this may be done by the art director in charge of developing a particular ad. Working with the cre-

ative and art directors are account executives, whose job it is to sell the agency's services to clients and then to represent their interests within the agency, sometimes by participating in the process of creating an ad. There are also the copywriters, who provide the words, or sales pitch, used in the ad. Any or all of these people may have an input in both the planning and the actual shooting, but the photographer's primary relationship is with the creative or art director, most of whom have an intimate knowledge of the field, a fair notion of the style and capabilities of the photographers they choose, and, therefore, confidence in the ideas a photographer can contribute to those already developed by his creative staff.

Smaller agencies, although they may also represent large corporations, can present a somewhat different situation.

Since they do not have the resources of the larger agencies, they may rely to a greater degree on the expertise, experience, and imaginative approach of the photographer, sometimes to the extent that he becomes, in effect, an art director, which puts him in the position of exercising a great deal of initiative. However, smallness can also have quite the opposite effect; it can inhibit risk-taking, and opportunities to be original and imaginative. There is less cushion for experimentation and less interaction among people approaching the problem from different perspectives.

The magazine's hierarchy is similar to that of the ad agencies, the art director being the photographer's main contact. Like their counterparts at the agencies, magazine art directors are concerned with design and photographic illustration as part of that design. But since their responsibility is to the overall look of the magazine rather than to a single product, they can afford to stress the aesthetic side of photography and to give the photographer greater freedom in working out

It is the responsibility of the fashion photographer, working with his clients, to present the latest trends in the ever-changing world of fashion in the most attractive and appealing way.

his own conceptions. The idea, of course, is to report on fashions rather than to directly advertise them, and it is the job of the magazine editors to initiate and develop story ideas that will present what is new and exciting in the world of fashion in the most attractive and appealing way. The pictorial concept that emerges is, therefore, a cooperative effort between the editors (who on the major fashion publications may have special areas of interest, such as women's fashion, men's fashion, and beauty), the art director, and ultimately the photographer.

Political Factors

In advertising fashion, particularly, there are occasional political considerations that enter into the planning and shooting of an ad. These have to do with the demands made by the company whose product is being advertised and, ultimately, with what the photographer can and cannot do. Pressures are exerted for various reasons. A company may be spending so much money on a campaign that it wants to make sure it is getting what it asked for. The advertising agency itself may feel the need to check over every detail of the campaign in order to prevent any slipups. And then there is the case of the very active corporate president who takes a personal interest in every aspect of his business and, instead of relying on the agency he has hired, imposes his own conception of the ad on the agency and the photographer.

The results of this kind of influence can be amusing or frustrating, depending on your vantage point. I had an assignment to do an ad for a large jewelry concern featuring rings and a very expensive necklace. One of the conditions was that I use a well-known and high-priced model the client had recently signed to an exclusive contract. Although a woman of unusual beauty, this model was not known particularly for the refinement of her hands or her neck, the very features on which I had to focus. During a session that went well into overtime, I tried every technique I knew to hide the flaws of those features. In the end, there was nothing left to do but to develop the photos and present them to the client. Fortunately, he saw the problem and ultimately called for a reshooting using a different model.

Personal Factors

With art directors, as with models, stylists, assistants, and others involved in fashion photography, the most important element of a working relationship is the personal one. Naturally, friendships develop among people in the field, but most important for the work is professional rapport. When an art director has confidence in his own creative abilities, he is likely to transfer that confidence to the photographers he hires. He will look for people who have something to offer beyond a strict adherence to the ideas presented to him by client and staff. Most art directors don't want a good soldier, but a creative person who will give and take, for they realize that the photographer has a special knowledge and inspiration that cannot be anticipated in any plan, no matter how thorough, so that in the end the photographer may have a lot to say about how the actual shooting is done. If the art director is less confident or, for some reason, must remain absolutely faithful to a comprehensive layout, the problem becomes one of getting the work done professionally and moving on to the next job, which may allow a greater measure of freedom. But even in extreme cases, it may be possible to shoot according to instructions and still offer an alternative that agrees more closely with the photographer's own style.

The Shooting

When it comes to the shooting session itself, the relationship between the art director and the photographer enters a new phase. Sometimes the photographer is left to his own devices, but more often the session is attended by the art director and possibly assistant art directors, copywriters or editors, account executives, and a host of other interested parties including, perhaps, a representative of the client whose product is being shown. But now they are in the photographer's domain, where all the elements that go into creating a picture—models, stylists, camera, lighting, and so forth—are under his direction. This is not to say that the art director and his staff should be ignored, even if they could be.

Quite the contrary. They are there to participate, and it is helpful to have their suggestions and approval rather than go off in the wrong direction. It may become apparent that a certain setup or pose is not possible or doesn't have the expected effect, anticipated in the planning stage, so that the art director and photographer must agree on adjustments and changes. Now the photographer's suggestions have a more immediate impact.

How much he participates depends on the individual art director. Some want to look through the camera to see what they are getting at all times. This may seem bothersome, but it is wise to encourage the practice. It satisfies his uncertainties and helps prevent mistakes. For instance, the shot may be set up so that there is not enough space for the copy. It is better to know this and to move the camera than to have to reshoot the scene because of a trivial error.

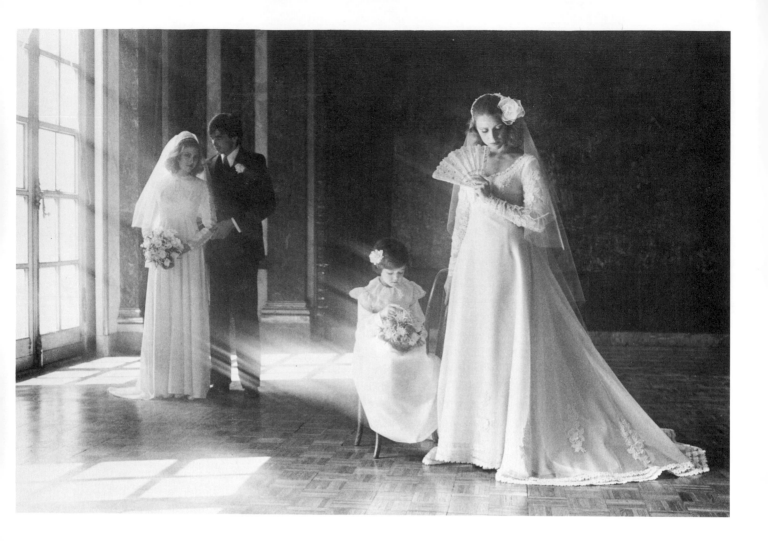

Of course, not all assignments run smoothly, and not all clients are absolutely enthralled by every idea that issues from the photographer. And there are times when the photographer wonders why he got into the profession in the first place. One such occasion in my career involved a small advertising agency that had just taken on a men's outerwear company as a client. The agency wanted to completely change the company's image by introducing a more casual and narrative way of showing the clothes, anything to get away from the rigid, tubular look that often blights men's fashion photography, and I was called in to confer on the possibilities. The agency, being small, was run by a president who involved himself in everything, and I had most of my dealings with him. There was an art director, but he was more of a figurehead. The president knew my work and thought we could find something within my style that would suit the new image he wished to create for his client. After many hours of working together, we came up with a number of ideas for vignettes that would show off the garments in a natural, intriguing, and sometimes risqué manner, and we were both quite excited about the possibilities they offered.

But somewhere between this planning and the shooting session, the president got nervous about the new image, and when we began to set up the first situation everything changed. Gradually and inexorably we moved back to the old image—the model standing stiffly by a chair and staring uneasily out of the picture rather than responding to a beautiful woman passing by; the garment as stiff as a suit of

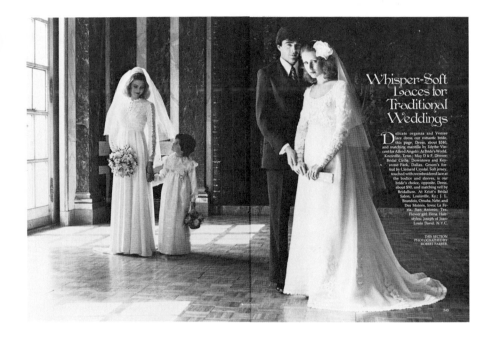

Delicate organza and Venise lace dress our romantic bride, this page. Dress, about $240, and matching mantilla by Edythe Vincent for Alfred Angelo. At Bride's World, Knoxville, Tenn.; May D & F, Denver; Bridal Circle, Downtown and Keystone Park, Dallas. Groom's formal by Clement Crystal. Soft jersey, touched with reembroidered lace at the bodice and sleeves, is our bride's choice, opposite. Dress, about $90, and matching veil by Bridallure. At Kristi's Bridal Salon, Louisville, Ky.; J. L. Brandeis, Omaha, Nebr. and Des Moines, Iowa; La Feria, San Antonio, Tex. Flower girl, Elena. Hairstyles, Joseph of Jean-Louis David, N.Y.C.

THIS SECTION PHOTOGRAPHED BY ROBERT FARBER

Sometimes, even the editorial pages call for greater detail to the merchandise than to aesthetics. In this layout for Modern Bride *magazine, the photographs were taken in various ways so that the art directors and the editors could have their choice whether to use a more mood-oriented photo, or one that paid more attention to the garment itself. (©Modern Bride magazine. Art Director: Sunday Hendrickson.)*

armor rather than moving with the figure; the lighting harsh and realistic rather than soft and enticing—as the president involved himself more and more in every aspect of the shooting. He began by looking through the camera, then posing the models, moving the props around, and arranging the lighting, so that finally there was nothing left for me to do but click the shutter. I did manage to salvage some of my effects, but it didn't really matter with all the other changes that were being made. Several times I thought of throwing my hands up and ending the session right there, but somehow it tottered to a conclusion and I vowed never to work with that client again.

Finally, of course, it doesn't pay to throw one's hands in the air, because a professional reputation is one of the principal assets a photographer has. He must be prepared for the fact that not all assignments achieve the same high level. There are occasional clashes of personality, some extreme cases of discomfort, and jobs that do not turn out as one had hoped. But there are certainly many more situations in which the photographer has ample opportunity to learn and to express his ideas. The important thing is to maintain the same enthusiasm for every job, to treat each as though it were the first and most exciting in his career.

CHAPTER FOUR

Putting the Shooting Together

There are shooting sessions that have the tranquil and intimate character of an artist painting a portrait. Working alone in the studio, the photographer quietly circles the model, considering different angles, changing the fall of a dress, shifting the lighting. Photographer and model complement each other, moving into the rhythm and flow of the mood they are both trying to achieve.

Other sessions resemble a movie set, sometimes approaching the proportions of a Hollywood epic. The setting is an impressive outdoor location. Props are constantly changed and moved around. Several models arrange themselves into a dramatic vignette, then regroup into another combination, then change clothes for a new shot. Hair stylists and makeup artists prepare other models for their appearances. The photographer and stylist weave in and out of the scene, making sure the models are positioned correctly, the clothes appear natural and comfortable, the desired dramatic effect is being expressed.

Sometimes a fashion photographer's session resembles a movie set, with several models arranged so as to complement one another. The photographer becomes the director, bringing the various elements together. (Bloomingdales. Art Director: Michele Bontempo.)

Art directors, editors, and their assistants watch intently and occasionally confer with the photographer while executives of the sponsoring company observe.

In this situation, the photographer becomes not only an artist but also a director and producer. It is his job to bring together all the various elements and to make them work together smoothly within the allotted budget and schedule—a task that requires much logistical planning and help from specialists in different aspects of the work. Preparedness, as they say, is all. If the photographer has done his job in planning the photos and layouts with the client and making the necessary arrangements for models, makeup, hair styling, location, props, and clothes, the shooting itself, barring a major breakdown of equipment or a change of heart on the part of the client, should flow naturally and efficiently from the preparations made.

Of course, each job introduces new circumstances and problems. In addition to creating and working out the concept of the photograph, the photographer has to make numerous calculations in choosing the correct models, hiring hair and makeup people who can achieve the desired style, finding a suitable location and being aware of the logistical problems it might present, coordinating the schedules of all the people involved, rescheduling a shooting in the event of rain, searching out props, considering the personalities of everyone working on the assignment and how they will get along together as well as with the client, and making sure that everything fits within the budget.

One of my assignments that involved most of these calculations was for a major manufacturer of men's clothing. Since the clothes were of European cut, the idea was to create an aura of cultured high fashion by setting the scene in a Paris café. Ideally, we would have shipped the models and everyone else off to Paris, but there was no budget for this along with all the other expenses. So we began to think about locations in New York that might simulate the atmosphere we desired. We inquired about a French sidewalk

café in the city, but the Police Department was not pleased with the prospect of having the sidewalk blocked for several hours. The front of the Metropolitan Museum, with its Beaux-Arts architecture and fountains, seemed the perfect spot, but, again, we couldn't get permission to set up the props. We finally settled on the charming Bethesda Fountain section of Central Park and were able to create a scene that might be mistaken for a café in the Bois de Boulogne or the Jardin des Tuileries. Fortunately there were no American signs to interfere with the Parisian image, although it was necessary to keep an eye out for hot-dog vendors and other very un-French passersby who would occasionally wander into the camera's angle of view.

Faced with the problem of photographing bathing suits in the dead of winter for Bloomingdales department store, I found the solution by using an indoor pool as the location for the shooting. The lifeguard's chair turned out to be the essential prop in the picture, too.

Propping the scene to attain authentic French touches also presented some difficulties. The fake café had to be put together from scratch, and it was not possible, within the budget, to rent all the chairs, tables, umbrellas, place settings, and ashtrays necessary to make the scene authentic. Real French chairs and tables were not available, so we ended up with the type found in American ice cream parlors. With the budget running over, we were able to obtain table umbrellas and ashtrays free by offering credit to the manufacturers of a French aperitif and a popular French beer.

For the ad, we booked a total of six models, men and women, including a character model to play the French waiter, who had to be outfitted in the proper costume. Since they were all popular models with busy schedules, we had problems setting up a date on which all of them could appear and then, because it was an outdoor shooting, of planning an alternative date in case the shooting had to be postponed due to rain. (This alternate date is called a "weather permit.") Finally, when the shooting took place as scheduled, we had to contend with making the models look casual and natural in their summer fashions on a chilly March day.

The Stylist—A Jack-of-All-Trades

Throughout the planning and shooting of this assignment, I had the invaluable help of a stylist, the jack-of-all-trades of fashion photography. The stylist is often the first one called to help plan and organize a shooting. His function may be limited or comprehensive, depending on the nature of the assignment and the budget, but there are a number of stylists who can do everything but direct the shooting and take the pictures. Most are equipped to find locations and props, to select the appropriate models and book them, to coordinate the clothing to be used in a shooting, and to work on the set itself, making sure that clothes hang properly, and even ironing the clothes while the models are preparing for a new scene. Of course, all these activities are carried out under the direction of the photographer. It is his ideas, or the ideas that have been worked out with the client, that must be fulfilled.

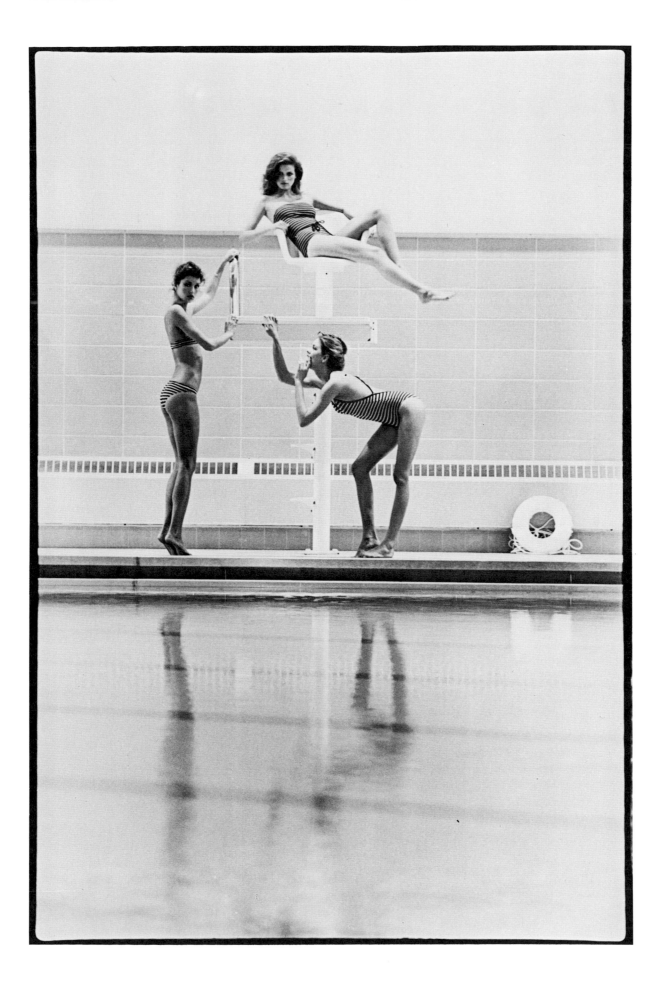

The photographer may want to make use of one or all of a stylist's services. An appropriate location may be the only thing required. Some stylists will not work with locations, but most of them keep files of public and private places that can be used to achieve various effects, for instance, a botanical garden as a colorful background for spring fashions, a townhouse with a drive-in courtyard to suggest elegance and wealth, a historic restaurant that can evoke a nostalgic ambience. A good stylist or location finder (those who specialize only in this area) will know or be able to figure out how and where to find the most unlikely and exotic settings within the confines of a modern city or its environs, whether it be an ancient fortress, a Roman bath, or an ultracontemporary business office.

When it comes to props, the stylist will have his sources for whatever is needed: antique stores, flea markets, theatrical costume and propping agencies, department stores, and possibly his own collection that he has accumulated over the years. If an eighteenth-century setting is needed, he will search out a store that has Louis XIV furniture. If the shooting involves children's fashions in the park, the scene might be complemented by a bunch of balloons bought in a five-and-dime store. Many props are rented or bought, but it is also possible to obtain almost anything on loan or by trading the use of a prop for a photographic credit, and working out this kind of agreement, if necessary, is one of the jobs of the stylist.

This dress, shot as a personal assignment for the videotape about how I work, had a very "art nouveau" feel, so I posed the model in such a way that the attitude of her head and hands had the same feeling. The most interesting aspect of the dress was its unusual back, so we photographed it that way. The ends of the dress were tacked to the black seamless paper, and the entire shot was lit with a single light source.

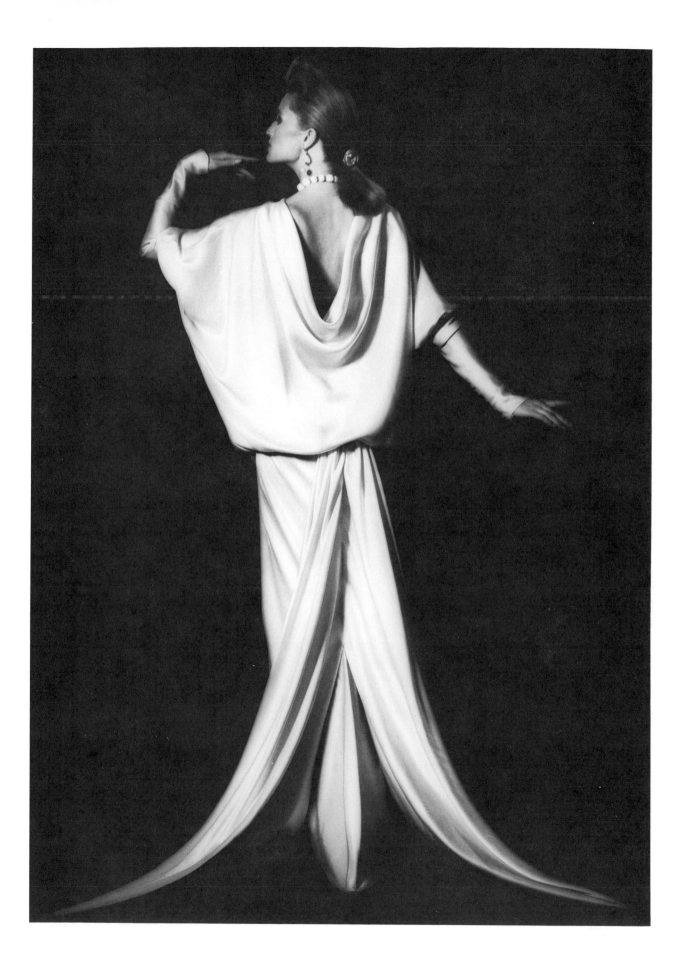

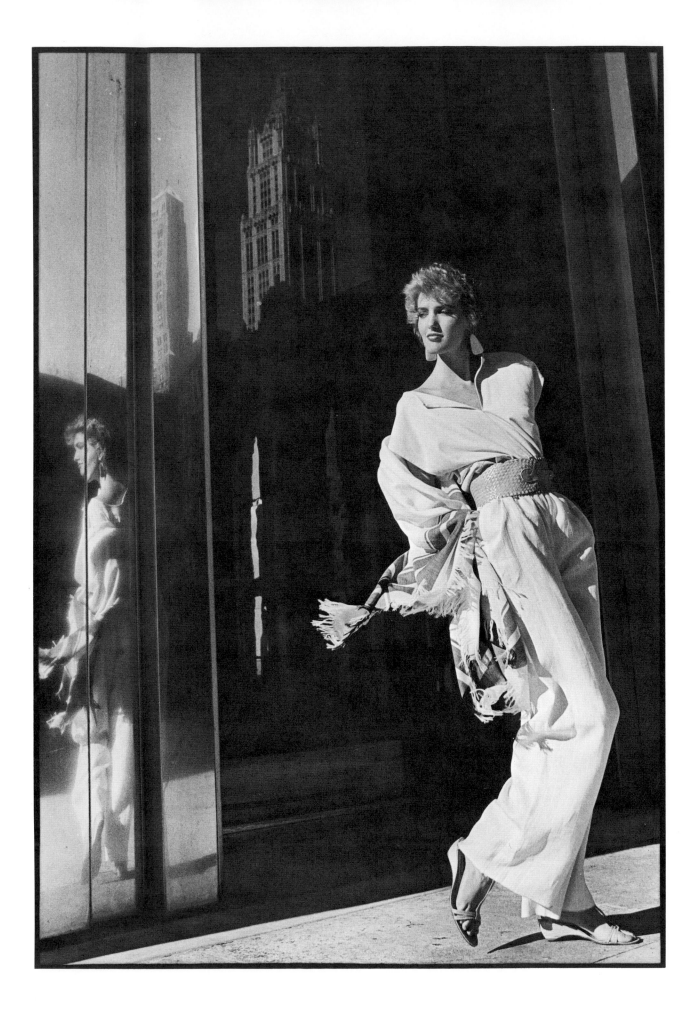

This photograph of a Calvin Klein out-fit, shot for a major store catalog, was done on location entirely with available light. I chose this particular setting because I felt the outfit needed a background that said "city," and I especially liked the way the reflections of the building and model turned out. Again, what really brought the picture together was the model's professionalism and her ability to project a feeling of movement—as opposed to standing stiff in front of the camera. In the photograph below which was shot in the studio, the simultaneous feeling of movement and tension is created almost entirely by the strange tilt of the camera.

All this preparatory work can be done by the stylist after the assignment has been discussed with the photographer. As confidence in the relationship grows, the stylist will not only take greater responsibility for making all the practical arrangements, but will also become an indispensable consultant, making available his own knowledge and imagination in working out the photographer's conception. He may also have suggestions regarding models, and indeed is sometimes entrusted with finding the right models for a scene and booking them, although the photographer should always make the final bookings and give final approval to all arrangements so that he is absolutely sure nothing is overlooked.

There are times when all the functions of the stylist must be fulfilled by the photographer himself, particularly when there is no budget for one. The photographer may find it quicker and easier in some cases to make arrangements based on his own knowledge. In my travels in New York and other places, for instance, I always make mental notes whenever I am struck by the possibilities of a location or a store specializing in items that might be useful in propping. Whenever possible, I try to take Polaroid shots of potential locations. For the photographer who may have more time when first starting out, there is great value in doing much of this work himself, building up his store of knowledge for present and future assignments, until he has confidence in a stylist who can complement or replace his own efforts. But when a photographer is busy and juggling several assignments, the assistance of a stylist is essential. When doing several jobs in succession, it would be impossible to schedule shootings for some without relying on someone else to organize the others.

On some assignments, a stylist may not be needed at all, or only up to the point of the shooting, during which the client (usually editorial) would supply his own people to keep an eye on wrinkled dresses or untied shoelaces. The role of the stylist is also diminished when the client comes up with his own models, locations, and props.

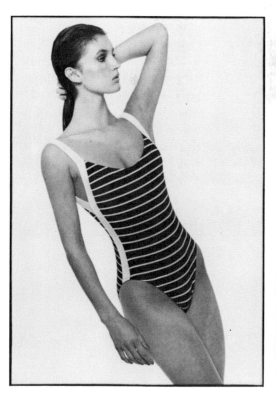

The Specialists—Makeup Artists and Hair Stylists

The participation of the stylist can even extend to helping with hair and makeup, which can be an advantage with a tight budget, but normally these tasks are done by specialists. With all the other work the stylist has to do, especially on a big assignment, it is necessary and desirable to have both a hair stylist and a makeup artist on the set. If the assignment involves many models, it may even be more efficient and economical to have more than one of each, so that shooting can continue while other models are being readied for succeeding shots. But there are people who perform both tasks, and this can be an advantage at times.

The photographer is likely to return again and again to the stylist with whom he has built up a confident working relationship. Rapport is important with hair stylists and makeup artists, but not to the same degree. One is more likely to select them on the basis of their style; they are, in a sense, artists, and each has his own way of doing things. Makeup artists are essentially painters of the face, and hair stylists sculptors of the hair, and the photographer has to determine how their work will fit in with his conception in order to use them. For instance, if he wants something theatrical and exotic, he will get a makeup person who has a flamboyant or stylized approach, or a hair stylist who can completely reshape the hair. On the other hand, such an approach would be ridiculous for a natural, outdoor look, so he would then choose someone with a much lighter touch who can get the most out of the natural looks of the model.

On the set, these specialists are very important people indeed. Their work is painstaking and often consumes much time, sometimes hours, to achieve exactly the right effect. It is important that such work be done to the artist's satisfaction, but it also takes away time from shooting and can upset a tight schedule. This is why it is necessary to know how a person works and to prepare accordingly so that every aspect of the shooting can flow smoothly. Personality is particularly important here, because if the hair and makeup people don't get along with the models or the art director, the long time it takes them to do their work—time in which other people are kept waiting on the set—will be filled with impatience. This is one aspect of the shooting which requires all the diplomacy the photographer can muster.

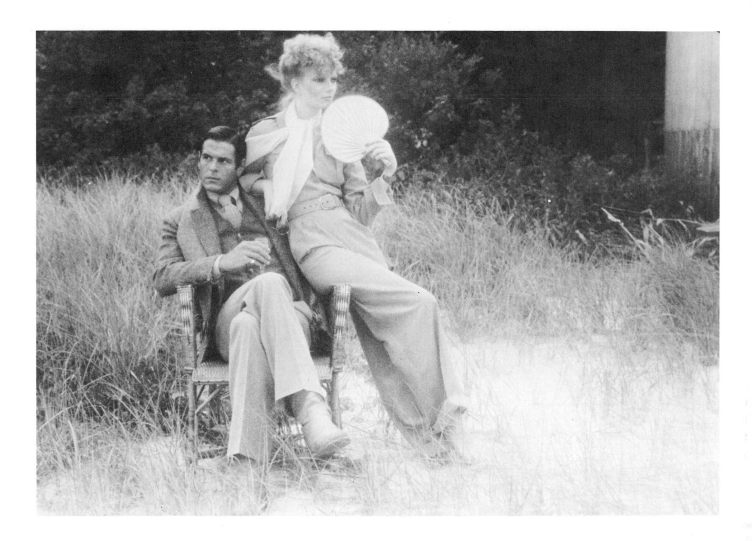

Pay Rates

The rates paid to stylists can vary, depending on the experience and reputation of the artist. The fees for hair stylists and makeup artists are roughly the same. A standard might be approximately $75 to $100 per hour and $500 to $600 per day. For some assignments, usually editorial ones, where there is little or no budget and the photographer's pay rate is lower, it is often possible to negotiate lower rates or even to offer a credit line in lieu of payment to hair and makeup people. Just as it does for the photographer, credit in a prestigious magazine can have a value beyond any immediate monetary one. Stylists' fees are also more flexible. A stylist just starting out may charge very little just to make himself known. If he is only finding a location, he may charge a flat rate of, say, $75. When he is more totally involved, the charge is more generally figured on a day rate, as mentioned previously.

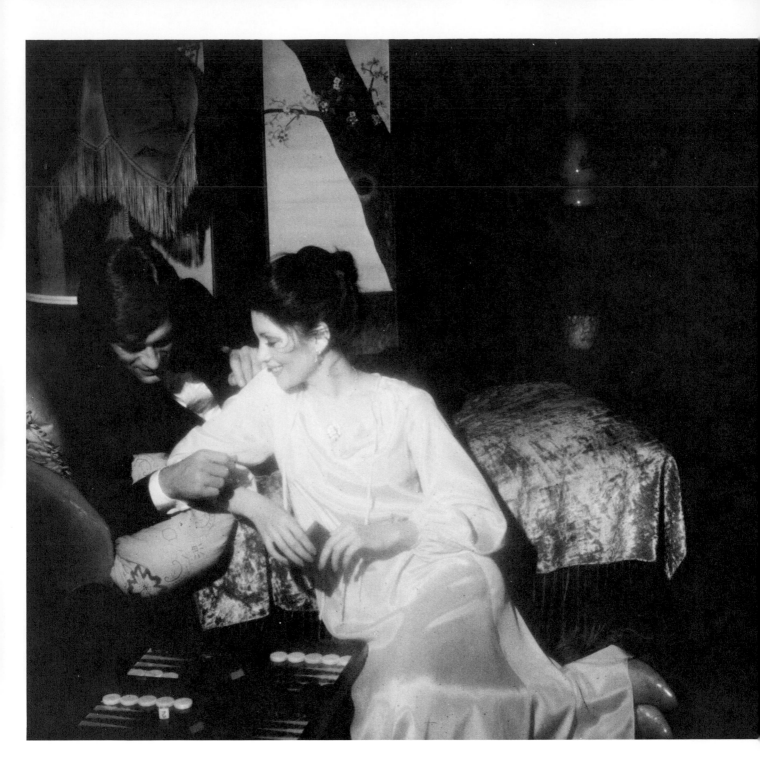

The Model

At the center of all this activity is the model. With the exception of some still-life product shots, very little in fashion photography is done without a model. It is she or he who makes the picture come alive, which is why great models come at a great premium. How well the models are chosen has an important bearing on the success of the photograph. Of course, there is no choice when the client insists on a certain model, either because they want complete control or because the model is associated with the product. This can lead to disaster if the client is unaware of the subtleties of photographing certain models for certain features. On the other hand, before going

Whether or not a fashion photographer is successful ultimately depends upon the model. The process by which a photographer chooses his model is like that involved in casting a movie. A model must be able to move, pose, assume a role, achieve a mood, as an actor or actress does. It is the attitude of his model through which a photographer is able to express himself.

ahead and making his own choices, it is wise for a photographer to ask a new client which models he likes to work with. In a working relationship that has not had a chance to develop, the photographer

doesn't know what is going on behind the scenes, who is coming up with ideas, and who is criticizing whom, and so it is best to avoid blame for an unsuccessful shooting by giving the client the responsibility. With clients he knows and has worked with successfully, the photographer has the chance to exercise his own choice, and this is where a series of complex aesthetic and personal considerations enter.

The first thing the photographer considers are the model's features. Most models are tall—about five feet seven to five feet eleven inches for women, and five feet eleven to six feet two for men. Clothes sizes range from 8 to 10 for women and 40 to 41 regular, sometimes long, for men. Within these rather enviable limitations, models are as individual and as different as any other group of people, and it is these differences which the photographer must be aware of and make use of. Every situation calls for a certain type of model—a woman who is sultry,

sweet, vivacious, healthy, winsome, severe, or open; a man who is worldly, rugged, courtly, mature, athletic, or boyish. It depends on the kind of look and mood the photographer desires. If he wants high-society elegance, an American or European look, cabaret funk, suburban sleek, or oriental exotic, there are certain models who can fill those roles. It is a version of casting that has its counterpart in the movies.

For many fashion photographs, the photographer may also have to pay attention to specific features. Some models are known for their work in lipstick ads because they have full, sensuous lips. A pantyhose ad would require long, shapely legs. Hair, eyes, ears, noses, hands, fingernails, feet, necks, and derrieres all become specialties for those ads which focus on particular features. Some models may be too buxom to show off a flowing evening dress, while others may be too slender to fill out a pair of jeans.

Model/Photographer Rapport. Modeling, like acting, is not just a matter of looks. It is a profession that involves skill as well as natural talent and beauty. The model must be able to pose, move, and take direction just as an actor does in a play or movie. The model is assuming a role and must be able to move into it with animation and expression that show the product off to best advantage and achieve the desired mood or dramatic effect. This is why rapport is such an important part of any shooting. The relationship between model and photographer should be a reciprocal one in which the model might even change or modify the situation, thus contributing something in her own movement or expression, which the photographer might not have anticipated.

At times, there are many instructions for setting up a scene. The ideal in a shooting session is to achieve the kind of relaxed atmosphere in which the work will proceed smoothly. But there occasions, especially those involving beauty products such as lipstick, cosmetics, or hair products, when the photographer doesn't have to say a word to the model. They find themselves in a one-to-one relationship, particularly when the camera work is closeup. The lighting is right, there is music in the background, and photographer and model each become more and more attuned to the rhythm of the other's mood and movements. It is like a romance; a mutual feeling develops, and in that situation words are unnecessary. With other kinds of pictures, talking and kidding around help to loosen things up. It all depends on the mood of the picture.

How models work with the others involved in the shooting is another important consideration in selecting them. Clashing temperaments can make a shooting session extremely difficult, as can a model who constantly complains about the way she or he is being made up, dressed, posed, or shot. Even when the model has exactly the features and talents you need, this kind of interference becomes an overwhelming reason for not using that model in certain situations.

The choice of models is also contingent upon how they look together, whether the photographer wants contrasting or similar types, and how they relate in height and other physical characteristics. Misunderstandings about height, for instance, can lead to rather strange and amusing problems. I once booked two European models, assuming they were the same height. When they showed up, however, one was substantially taller than the other. It turned out that the metric measurement for her height that appeared on her

page 65

elite

Elite Model Management Corporation

John Casablancas

150 East 58th Street, New York, N.Y. 10155

Tel. 935-4500, T.V. 935-4558, Telex: Modelite 428546

Carol Alt
5'9½ Size 8 Shoe 7½-8 Medium Brown Blue

Suzy Amis
5'8 Size 7-8 Shoe 8½M Strawberry Blonde Blue-Green

Andie
5'8 Size 8 Shoe 8½ Brown Hazel

Andrea
5'9 Size 8-9 Shoe 9 Dark Blonde Green

Gunilla Bergström
5'9 Size 8-10 Shoe 7½ Blonde Blue

Lisa Berkley
5'9 Size 8 Shoe 7 Auburn Blue

Sophie Billard
5'9½ Size 8 Shoe 9 Medium Brown Hazel

Bitten
5'9 Size 8-10 Shoe 7½-8 Blonde Blue

Lise Brand
5'8½ Size 10 Shoe 8½ Medium Brown Blue-Green

Carrie
5'9 Size 8-10 Shoe 8 Honey Blonde Blue-Green

Phoebe Cates
5'7 Size 5-6-7 Shoe 7 Brown Brown

Charlotte
5'9 Size 8 Shoe 7½ Dark Blonde Grey-Blue

Marilyn Clark
5'8½ Size 6-7-8 Shoe 7½ Blonde Blue

Pia Darin
5'9 Size 8 Shoe 8½ Strawberry Blonde Blue

Nancy Decker
5'9½ Size 6-7-8-9 Shoe 9M Red Green

Debbie Dickinson
5'8½ Size 6-9 Shoe 9 Dark Blonde Green

Janice Dickinson
5'10 Size 7-8-10 Shoe 8½-9 Brunette Brown

Peggy Dillard
5'10 Size 8-10 Shoe 9½ Dark Brown Brown

Nancy Donahue
5'9 Size 7-8 Shoe 7½ Blonde Green

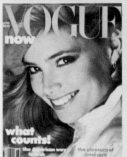
Kelly Emberg
5'9 Size 6-7-8 Shoe 8-8½ Blonde Blue

Kelly Emberg

Height 5'8 Dress Size 6-7-8 Bust 34 Waist 24 Hips 35 Shoes 8-8½ Hair Blonde Eyes Blue
Hauteur 1.73 Confection 36-38 Poitrine 86 Taille 61 Hanches 89 Chaussures 39-39½ Cheveux Blonds Yeux Bleus

SAG

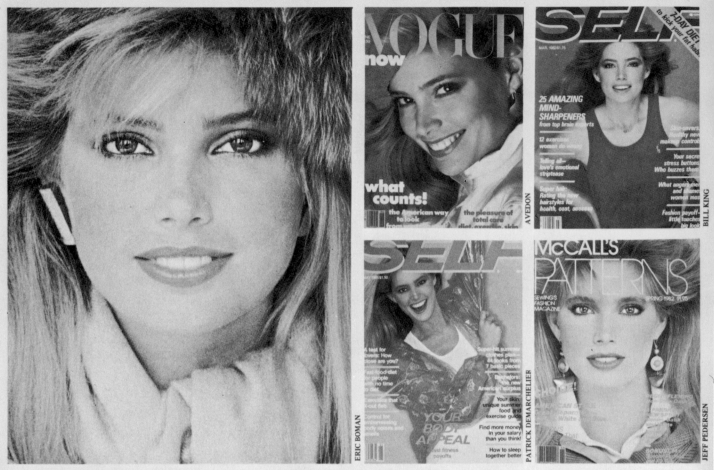

AVEDON

BILL KING

ERIC BOMAN

PATRICK DEMARCHELIER

JEFF PEDERSEN

agency card had been incorrectly translated into feet and inches. But I was stuck with the booking and so made the best of the situation by posing them on different levels, or having one of them bend over to fix her shoe. In so doing, we changed the conception of the photos.

With experience, a photographer gets to know which models he prefers to work with and may even become identified with them. For most assignments, he will have certain models in mind immediately. If not, the stylist may have suggestions, or the modeling agencies, which are always willing to suggest models so long as they know the type of model the photographer needs. The agencies also put out head sheets containing pictures of all the models they represent, along with information about height, color of hair, color of eyes, shoe size, and dress or suit size. Some models have elaborate brochures, called "composites," showing some of the ads or layouts in which they have appeared, and giving a more complete idea of how the model looks, moves, and expresses herself. Then, of course, there are also the fashion magazines themselves through which the photographer can familiarize himself with almost every model who is working.

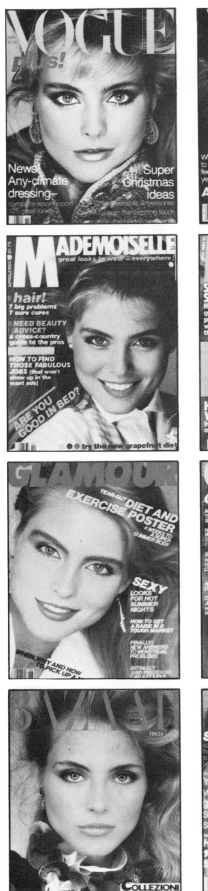

The model composite is actually the model's business card. It is, in essence, a brochure containing several photos, ranging from head to bathing-suit shots, each picture capturing a different look, to show the versatility of the model. In recent years, these composites have become quite an impressive presentation, outstandingly designed and pictorially informative.

Carol Alt

Height 5'9½ Dress Size 8 Bust 34 Waist 25 Hips 34 Shoes 7½-8 Hair Medium Brown Eyes Blue
Hauteur 1.76 Confection 38 Poitrine 86 Taille 64 Hanches 86 Chaussures 38½-39 Cheveux Chatains Yeux Bleus
S.A.G.

Andie

Height 5'8 Dress Size 8 Bust 33 Waist 24 Hips 35 Shoes 8½ Hair Brown Eyes Hazel
Hauteur 1.73 Confection 38 Poitrine 84 Taille 61 Hanches 89 Chaussures 39½ Cheveux Bruns Yeux Noisettes
S.A.G.

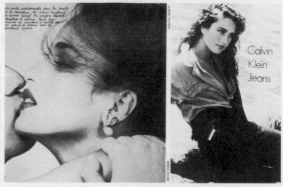

Andrea

Height 5'9 Dress Size 8-9 Bust 34B Waist 24 Hips 35 Shoes 9 Hair Dark Blonde Eyes Green
Hauteur 1.75 Confection 38-39 Poitrine 86 Taille 61 Hanches 89 Chaussures 40 Cheveux Blonds Fonces Yeux Verts
SAG

Nancy Donahue

Height 5'9 Dress Size 7-8 Bust 33 Waist 23 Hips 33 Shoes 7½ Hair Blonde Eyes Green
Hauteur 1.75 Confection 38 Poitrine 84 Taille 58 Hanches 84 Chaussures 38½ Cheveux Blonds Yeux Verts
S.A.G.

Iman

Height 5'9 Dress Size 6-8 Bust 32 Waist 23 Hips 35 Shoes 8 Hair Black Eyes Black
Hauteur 1.75 Confection 36-38 Poitrine 81 Taille 58 Hanches 89 Chaussures 39 Cheveux Noirs Yeux Noirs
SAG

Joan Severance

Height 5'9½ Dress Size 6-8 Bust 34 Waist 23 Hips 35 Shoes 8½ Hair Brown Eyes Blue
Hauteur 1.76 Confection 36-38 Poitrine 86 Taille 58 Hanches 89 Chaussures 39½ Cheveux Bruns Yeux Bleus
SAG AFTRA

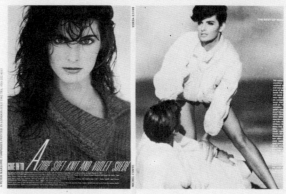

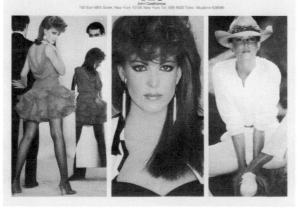

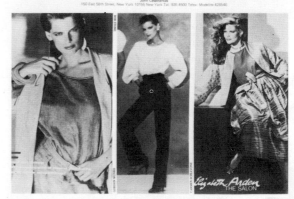

Booking Models

Before engaging a new model, it is important to ask the agency for his or her portfolio and to arrange for a meeting, a practice known as a "go-see." This is important not only to determine how the model looks, but also whether there is the kind of personal rapport that will result in interesting photographs and an easy working relationship. If the relationship is stiff and uncomfortable on a personal basis, it more than likely will remain so when a camera is interposed. In New York, the go-see is an accepted part of the whole process of selection, for top models as well as beginners. However, in the much tighter world of fashion photography in Paris, one is expected to book models without having to see them first.

Booking models can be a tricky business, particularly when there are several models involved and their schedules must be coordinated. Once it has been determined who to use, the photographer or the stylist calls the agency and makes a "tentative" booking, giving the date of the shooting and the length of time the model's services will be required. If the model is unavailable on that date, it may be necessary to either change the date or choose another model. If the model has already been tentatively booked by another photographer, a "secondary" booking can be made. This becomes a tentative booking only when the first photographer cancels. During the tentative period, a booking may be cancelled at any time without any problem, in the event that the shooting has to be postponed. A "confirmed" booking, must be made at least 48 hours before the shooting, and once this is done, the photographer is locked in and must pay the model's fee whether the shooting takes place or not. In order to avoid misunderstandings in a situation that often involves precise timing and coordination, the photographer should always make the final booking himself.

In scheduling a shooting, the photographer does not always know exactly when it will take place, and it is therefore necessary to maintain some flexibility. With half-day sessions, for instance, or those which take only an hour or two, the art director may call before the final booking and change the time from the morning to the afternoon, or vice versa. Although the agencies and models don't particularly like the practice, because it ties up their schedules, it is wise in such cases to tentatively book a model for the whole day and then specify the exact time, morning or afternoon, when the final booking is made. An added problem also arises when the shooting is to take place outdoors. Then, it is necessary to obtain a "weather permit" from the agency for each model so that the shooting can be rescheduled in the event of inclement weather. And, of course, the models' rain dates must correspond. They must still be paid for the initial date,

Model Booking Schedule

© robert farber

client: **Saks Fifth Ave.** date of shooting: **3/2** weather permit date: **none**

Location: Waldof Towers

model	agency	height	hair	size	time of booking	tentative	secondary	confirmed	rate	
Christie Brinkley	Elite	5'8"	Blond		all day	✓		✓		
Maria Hanson	Wilh.	5'9"	Blond		all day		✓			
Patti Hansen	Wilh.	5'8"	Black		all day					
Julie McClay	Elite	5'8½"	Brown		all day	✓		✓		
Winnie	Elite	5'8½"	Blond		12:-5:00		✓			
Ingo	Wilhem.				10:-1:00	✓		✓		
Franziska Carrara	Wilh	5'9"	Blond		all day	✓				
Erika De Kobal	Zoli	5'8"	Blond		all day	✓				
Pia Gronaing	Zoli	5'8"	Black		all day	✓				

though only at half rate, and at full pay for the actual shooting time. Since this kind of reshoot costs the client both in time and money, it should be avoided whenever possible.

One of my ad assignments seemed doomed to be interrupted by rain, but somehow we managed to work around it. The ad involved two separate scenes, one for formal wear, the other for casual wear, both to be shot in a half-covered driveway. Although it was raining, we managed to get through the formal part without much problem. When it came to the second shot, the models, along with hair and clothes, had begun to look a little droopy. Although they were protected, it became more and more difficult to change clothes and set up the shot to avoid the effects of the rain. The client, who was attending the session, suggested that we try another day. I managed to convince him that we had nothing to lose by putting things in order as best we could and finishing the shooting. If the photographs were unsatisfactory, we could always schedule another date anyway. As it turned out, the effects of the rain were not evident, the pictures were fine, and a substantial extra expense was avoided. These extra efforts are well worth the trouble, as clients do not easily forget a photographer's enthusiasm and economy.

Model Fees

Model rates are fairly standard, although many of the top models don't even quote rates but negotiate compensation depending on the kind of job and budget involved. Rates do go up from time to time, but the starting fee for beginning models in New York is $1,000 per day. Most established or popular models get $2,500 to $3,000 per day. Models can also be booked for half and quarter days. Once again, as with stylists, hair and makeup people, the model may work at a reduced rate if a low-budgeted assignment offers exposure and prestige, as in editorial fashion.

I have found myself totally unorganized when trying to book models, filling up scrap paper with myriad names; dates; listings of information such as height, hair color, sizes, and notes of tentatives, secondaries, and many cross-references; to the point of utter confusion. I finally decided I had to do something. The form reproduced at left is what solved my problem.

New York Agencies

Agency	Address	Approximate Number of Male Models	Approximate Number of Female Models
Ford	344 E. 59th St., 10022	80	147
Zoli	146 E. 56th St., 10022	80	120
Elite	150 E. 58th St., 10022	30	150
Wilholmina	9 E. 37th St., 10016	74	139
L'Image	667 Madison Ave., 10021	25 (European and celeb models, large commission division)	40
Legends	40 E. 34th St., 10016 Suite 1600	40	95
Prestige	80 W. 40th St., 10018		60
Sue Charney	641 Lexington Ave., 10022	25	60
Van der Veer	225A E. 59th St., 10022	20	40
CLICK	881 7th Ave., 10019	35	30

There are special rates for special situations, particularly those involving nudes or semi-nudes. First off, the model has to be willing to appear nude in front of the camera and the job has to be cleared with the agency and the model. If she is to appear in a bra, girdle, or pantyhose, the fee is $350 an hour; in a slip, $300; in a peignoir or night-gown, $300. The fee for complete nudity, which may be required for a bath oil or per-fume ad or an editorial layout, is $500 an hour, or $2,500 a day. All these fees apply only to the time the model is actually in front of the camera; the time spent in preparation is charged at a regular rate. These fees are also negotiable.

In this and other matters, a modeling agency serves not only as an intermediary but also to protect and promote the careers of its models. It has to know exactly what the shooting is about in order to determine

Most of the professional fashion photography done in the United States is centered around New York City, and that is where the top models are. Listed above are some of the major modeling agencies and their addresses. The top four agencies each have annual billings in excess of ten million dollars.

whether it will be beneficial or detrimental. For instance, photos for packaging, posters, billboards, and counter displays, since they can appear in any number of undetermined contexts, must first be cleared with the agency. If the assignment is for a product that competes with one the model is already associated with, the agency may veto a booking. For the most part, however, the agencies are helpful in selecting models and are anxious to have the people they represent work as much as possible. They encourage go-sees and also make models available for fittings, which are sometimes necessary when clothes are being obtained for a shooting, at a small percentage of the normal fee.

Although New York is the mecca of fashion in the United States, it is certainly not the only city where fashion photography is done. Many cities, including Los Angeles, San Francisco, and Chicago, have active modeling agencies as well as photographers who do both local and national fashion photography. In European fashion capitals such as Paris, London, and Milan, the availability of models usually makes it more economical and fitting, particularly if a European look is desired, to hire models from there rather than transport them from the United States. In more remote settings, however, where there are no modeling agencies, it may be necessary to book models who are willing to travel to the location for the time required and to sometimes work for a flat, pre-negotiated rate rather than for their usual hourly or daily fees.

Fortunately the burden of covering models' fees has been taken off the photographer's shoulders in recent years. In the past, modeling bills were sent to the photographer, who was then reimbursed by his client; nowadays, the client is billed directly. All other expenses, however, including stylist, hair stylist and makeup artist fees, rentals, and other out-of-pocket expenses, are still the responsibility of the photographer until he is reimbursed. However, the photographer should first try to have the more costly of these expenses (stylist, makeup artist, and hair stylist) billed directly. When this is not possible, most photographers prearrange to make payment when they receive reimbursement from the client. These financial arrangements, particularly for those just starting out in the field, give the photographer more freedom to complete a job without having to worry about the extra pressure of personal liability.

Teamwork

The pressures can be considerable. From the day the assignment is given, until its completion, the photographer must deal with a tremendous range of factors and problems, including the demands of clients and uncertainties of the weather, keeping firmly in mind the goal of all his organizational efforts, the cool and effortless images that transcend the turmoil that went into their making. This is why teamwork is the key concept in putting any shooting together, whether it be a simple session with a single model or a full-scale production with numerous models and supporting professionals. Ideally, the photographer works with people of his own choosing—the stylists, models, hair stylists, and makeup artists with whom he has developed a confident working relationship and rapport in carrying out his aims with the least amount of friction. But he does not always have the final say in choosing his co-workers, and it is then that all his talents as a producer, director, diplomat, and creative artist are called upon.

After a shooting, the model fills out a voucher slip. This voucher includes the hourly rate of the model and the times of the booking. The client signs it, which confirms the fee. The voucher also includes a model release which, when signed by the model, makes it unnecessary for the photographer to have a separate model release signed.

Studio or Location (Tools of the Trade)

In earlier years, most fashion photography was done in the studio. The reason was not only that there was an aesthetic preference for rarefied and highly controlled scenes, but also that it was impractical to shoot at real locations. The big view cameras were too heavy and cumbersome to allow anything but static posing, which is more appropriate to the confines of a studio than the freedom of a landscape. Film was too slow to accommodate changes in lighting conditions, either indoors or out, and it was almost necessary to work under the predictable and controlled lighting of a studio situation. Then, too, the widespread use of color film after World War II brought with it a new interest in natural settings that had not existed in the black-and-white era.

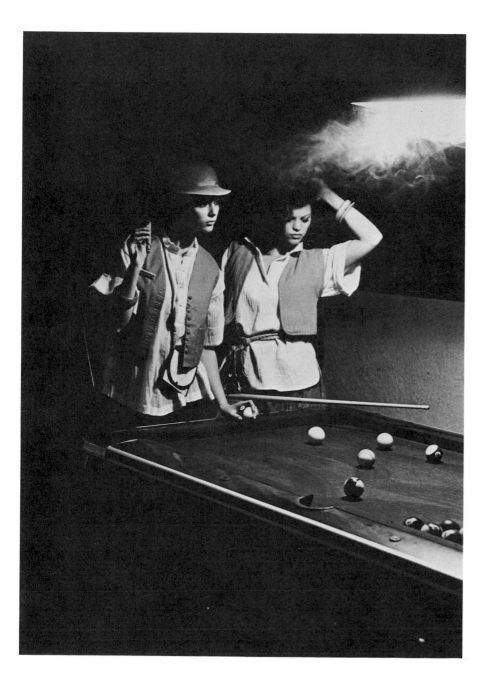

Photographing with natural light does not necessarily mean photographing with the light from a window. In this fashion photograph, the light used was the available room light, which added a realistic look to this poolroom scene. (Gimbel's. Art Director: Tom Smallwood.)

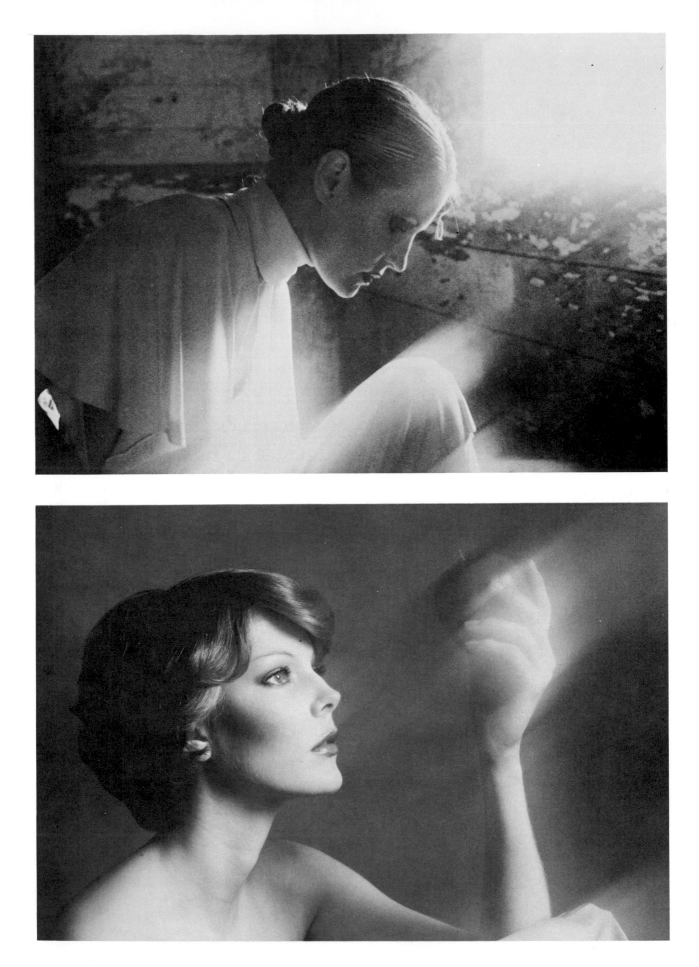

Lighting is one of the most important variables in fashion photography. Artificial lighting gives the photographer a range of control and can be manipulated to give him any effect he wants. One of these photographs was taken with natural light and the other with studio lighting, made to simulate outdoor light. The effect of the two pictures is the same.

Today, the photographer can obtain any effect he wants and can shoot under almost any conditions, if they suit his purpose. The development after the second World War of the miniature 35 mm camera, with its fast lenses, small size, and light weight, has made it possible for the photographer to set up shots—on location or in the studio, with artificial light or daylight—with far fewer limitations. The camera is no longer an encumbrance to the photographer, an obstacle between him and the subject.

Rather, it has become an extension of himself with which he can move and capture the movement of the model. The proliferation of lenses (telephoto, wide-angle, and macro), the ever-growing development of the camera body itself, and its accessories (through-the-lens viewing, through-the-lens metering, and motor drives), have increased the options in working with close-up or distant shots, low or powerful light, panoramic or tight views, distorted or undistorted form. The films produced in color and black-and-white for the 35 mm camera have also broadened its range of capabilities. All these improvements in the technology of photography have made the photographer's task easier in one sense, but they have also made it far more complex. In establishing a style that has the integrity of his vision, he is now faced with an infinite combination of choices from which he must extract the technical means to achieve his aesthetic goals.

Large-Format Cameras

The view camera has survived and is still used and even preferred by a few art directors and photographers. And it does have some advantages. The 4″ × 5″ or 8″ × 10″ view camera produces a large transparency or negative that can easily be retouched, and it is therefore favored by those art directors who want to eliminate every wrinkle and obtain lifelike sharpness while achieving an ideal image of a garment or beauty product. The 2¼″ × 2¼″ has the same advantage, although the film size is smaller and the format

ESSENTIAL EXTRAS
Diversification is an old ploy, but don't knock it. Accessories are the telling touches that separate the men from the boys, the pros from the amateurs, at the same time that they supply the essential note of conviction to a well-tempered outfit.

Sometimes fashion and beauty photographers are asked to shoot still-lifes as part of a layout. Many of these still-lifes are done with 35 mm, like this one photographed for Gentlemen's Quarterly. *Accessories are as much a part of fashion as a pair of pants. Even though they are inanimate objects, they should be photographed with the same feeling and mood as a flowing chiffon dress. (GQ. Art Director: Harry Coulianos.)*

square. For these reasons, the larger cameras have their greatest application in the fields of catalogs and still-life photography.

But there are also disadvantages with the large-format cameras. One concern is the availability of color film. There is no Kodachrome film for these camera sizes, a film most in demand for fashion and beauty photography because of its accurate rendition of color and its grainlessness. This fine-grained film, when combined with the quality optics of a fine

35 mm camera, can match the reproduction quality obtainable in the larger format cameras. Another disadvantage is the problem of their bulkiness, which is less acute with the 2¼″ than the view camera, and the intrusion of a technical mass hanging between the photographer and the model. Finally, because of their lack of mobility, slower lenses, and cumbersome system of advancing or loading film, the photog-

rapher must laboriously set up each view while the model waits on his machinations with the cameras. This inhibits movement and results in a stiff look. Missing is the spontaneity of pose and expression of the lighter, faster, more casual 35 mm.

The camera system I recently settled upon (after many false starts) is the Minolta system. Not only are the optics outstanding, but the system offers a number of exposure modes, many useful lenses and accessories, and the X-700 camera body is very light and convenient to use.

I must admit I was quite happy with my previous camera system until I discovered the Minolta one. For much less money, this system offered me a durable camera body with more features and a full selection of lenses—including some extremely versatile zoom lenses with focallength ranges not available from other camera manufacturers. I like to carry these zoom lenses when I do my personal art photography on location.

From the tremendous variety of Minolta lenses available, I constantly use three basic ones for my commercial work: the normal 50 mm, the 100 mm, and the 35 mm wide-angle. With these three lenses I can cover almost all my needs, although some photographers might favor a 28 mm wide-angle, or a 135 mm for tight head shots. My very favorite lens however is the 35-105 mm Minolta zoom lens, which I use for my personal work.

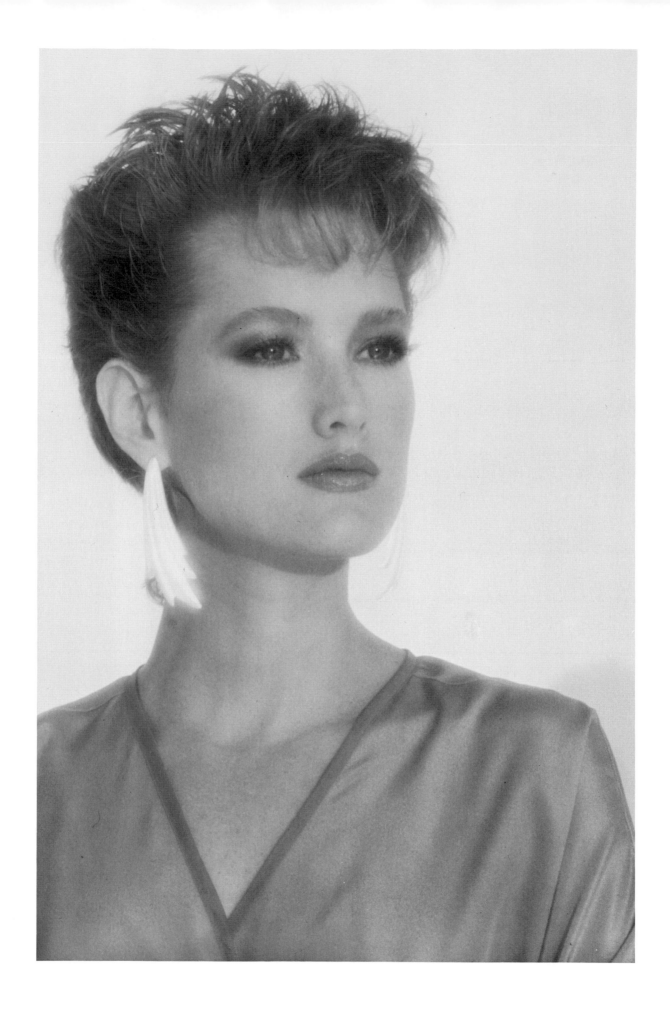

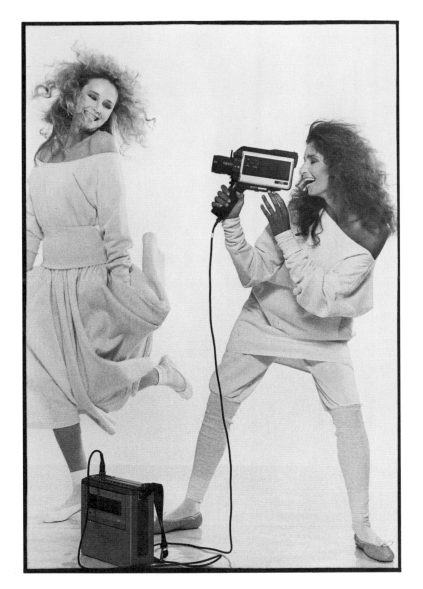

This shot of two models with a video-cassette recorder was done as part of a catalog for Jordan Marsh department stores. Shot in my studio, it's an example of the many times I've been asked to advertise both clothing and a product (such as an electronic appliance) in the same photograph. Doing so makes financial sense for the client, and can add a sense of fun and enjoyment to the object.

Telephoto Lenses. The long lenses (which start at at 90 mm) have several very important applications. They allow the photographer to do tight closeups without crowding the model, and are therefore often usd in the studio and elsewhere for beauty shots where it is essential to focus on the head or some detail of the body. The longer the lens, the less chance of distortion, for instance, a shot in which the nose looks too big in relation to the rest of the face, because the camera was not right on top of the model and therefore did not record perspectival depth to the same

degree. Long lenses also reduce the depth of field (the area in sharp focus within the space of the picture) as compared to a normal lens (50 mm) when used at equal apertures. This makes it possible to focus on the one depth where the subject is, eliminating or blurring both the foreground and background. In blurring trees, streetlights, and other areas of color, this creates an effective, sometimes dramatic, abstract design and therefore concentrates attention on the model and the product itself, a result that may have both aesthetic

appeal and appeal to the client whose product is being shown.

This effect is still more dramatically achieved with the even longer 500 mm lens. The problem with this has traditionally been its length and bulk, which make it difficult and usually impossible to handhold the camera. In recent years, however, a mirror lens has been developed (one whose focal length is increased by using the mirror within the lens housing), reducing the weight and size of the housing

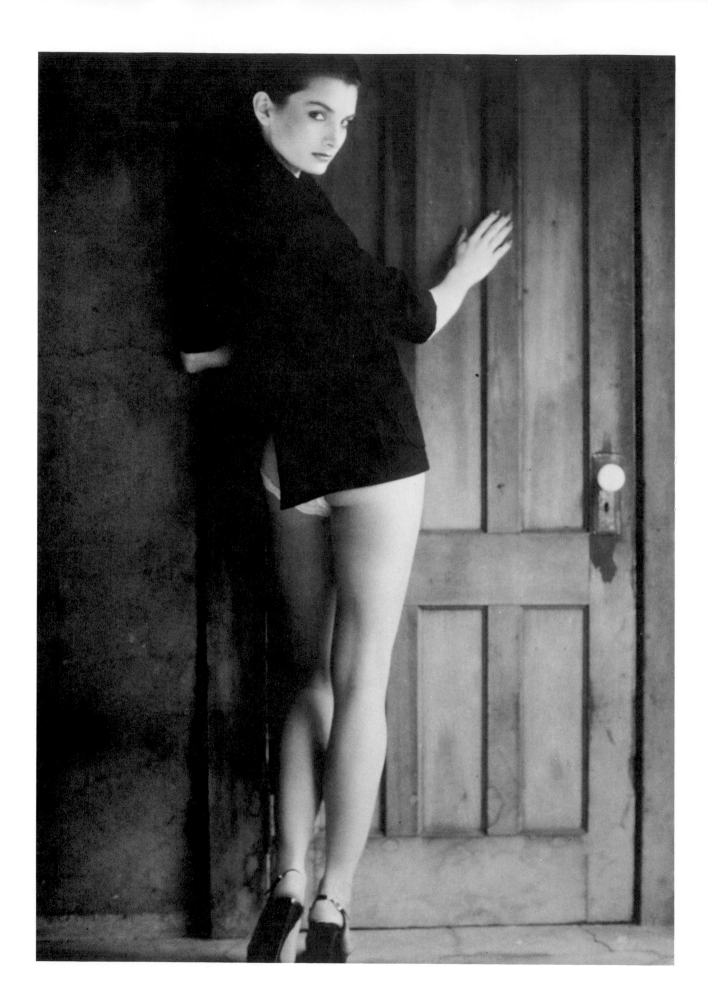

and thereby making the whole apparatus much more portable.

Wide-Angle Lenses. Any focal length below 50 mm is classified as a wide-angle lens. Some wide-angle lenses have focal lengths below 20 mm, and the ones from better manufacturers are relatively distortion-free. In general, however, wide-angle lens, rather than a fisheye. In general, however, wide-angle lenses will distort the image when used at certain angles to the subject. Some photographers use this distortion to advantage to create special effects that become the basis of their style. Wide-angle lenses provide a wider angle of view than the normal 50 mm lens. However, the most important reason for using them is to create some pictorial interest by exaggerating a particular feature, or by making a model appear taller and thinner, or by emphasizing the perspective of an object plunging into space.

Lens Versatility. The variety of lenses available today can be used in creative and practical ways, particularly when the photographer is restricted to a single location and must get the most out of it. On one assignment for a sweater manufacturer, I had about half an hour to do the actual shooting, because a lot of time had been spent in the dressing and makeup of the three models. So I took advantage of the surroundings as much as I could in order to vary the shots in the park setting we had chosen. I made several shots near a running fence using a normal 50 mm lens. I then composed the models along the fence and used a wide-angle lens to exaggerate its perspective, telescoping the figures more dramatically into space. A third series of shots was made using a 500 mm lens, with the models walking toward the camera. They actually had to pose as though they were walking, because of the fixed aperture of the 500 mm mirror lens, with its narrow depth of field, thus necessitating extremely careful focusing. The great magnifying power to the lens forced

me to stand so far back from the models that we had to station my assistant in-between to relay my instructions. In these shots, the foreground and background were focused out, making it impossible to tell that they were taken at the same location as the others.

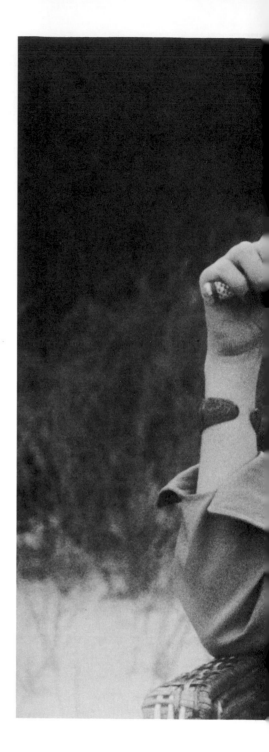

One prop may change the whole mood of a head shot. It can add a feeling of location to a studio photograph or make a cool day in March look like a warm day in July.

35 mm Film

The flexibility of the modern 35 mm camera and lenses is complemented by the versatility of 35 mm film. Most fashion photographers work in color and black-and-white, since the magazines run an equal amount of both. Koda-chrome is the preferred color film; it is the one most often asked for by art directors and, therefore, is the most widely used. The reasons are simple: Kodachrome is an extremely sharp and grainless film, which means it can be blown up in reproduction without losing any of its richness and con-tinuity of color. It has full, saturated color and good latitude in its exposure. Clients usually prefer it because it is extremely accurate in picking up actual colors, and it pro-duces beautiful, clean skin tones. There is no distortion of the product, and there may even be an added brilliance.

Agfachrome film, how-ever, which is now available in E-6 process (200 ASA), lends itself to more extreme situations and more imagi-native uses. It is faster than Kodachrome, which only comes in ASA 25 and ASA 64. In addition, Agfachrome 200 ASA can be pushed to much higher speeds. It is grainier

film than Kodachrome, does not hold color quite as well in reproduction, and if pushed, the emulsion begins to break up and has a tendency to color shift. Most clients are not interested in losing color and detail in this way, but these qualities can be used to create moods that cannot be achieved with the more realistic Kodachrome. Agfachrome's possibilities are more exotic, and its fast speed allows the photographer to shoot in more natural situations without the brilliant light that is required for the slower Kodachrome. Because it can be developed at local custom labs, Agfachrome 200 ASA also saves time when there is pressure to get a job done quickly, whereas Kodachrome must be sent to the nearest Kodak lab for processing.

With black-and-white film, there is no worry about color shift as the exposure changes, or about the problems of oversaturation with underexposure and washed-out color with overexposure. And, unlike color film, with which the photographer should do all the work through the camera before making the exposure, by using the proper lenses, films, and filters, black-and-white film can be altered in the darkroom, not only in the way it is printed, but also to achieve special effects. This is not to say that color cannot be altered in the darkroom; however, most color photography for reproduction in publications is done on transparency film, and the client does not receive prints as he does when the assignment calls for black-and-white. My favorite black-and-white film is Agfapan 400, though when I need especially fine grain I often use Agfapan 25 — or 100 ASA if I need more speed. Kodak Recording Film is extremely fast and light-sensitive, can be pushed to extreme speeds, produces a very grainy effect, and can produce exciting effects when used in the proper situation. I recently started to push Agfa black-and-white 100 ASA to 400 ASA and process it in a paper developer, which has given me a nice grain structure with a higher contrast.

The Function of Light

Everything in photography functions in relation to the intensity of light. Light can also determine mood, the quality of color, and the distinctness of form and detail. There are many ways to turn light to suit one's own purposes: by shooting into the source or away from it; by using filters to modify it in some way; by diffusing it to create a soft, romantic haze; or by employing a strong light source to create dramatic shadows. Outdoor light is conditioned by the weather and time of day. Although an occasional assignment might require a bright blue sky, fashion

photography is most effective on overcast days, when the light is diffused and the shadows softened. Some studios have access to natural light through windows or a skylight (preferably facing north), although much of the shooting is done with artificial light.

Artificial Light Sources. With artificial light, the photographer is working with an element over which he has much more control in terms of intensity, direction, and quality. For instance, a model can be lighted from the front to flatten out the image, or from the side to create more roundness or even bold contrasts of light and shade. Lighting can be direct or indirect, depending on whether the desired effect is a harsh or subtly lit image. Furthermore, the intensity of light can be increased to achieve greater depth of field.

Tungsten and strobe are the two basic types of artificial lighting. Because tungsten is a steady source, it is possible to see the exact amount of light, how it is falling, and what shadows are being produced.

With strobe, the photographer doesn't have quite the control, because it is a flash system. By using modeling lamps built into the strobe head, he can get a general idea of the light in relation to the subject, but it does not accurately indicate the intensity and impact of the flash of light thrown off by the strobe. Nevertheless, strobe has many advantages and is the most popular form of lighting among fashion photographers. First of all, it approximates sunlight, falling within the same color temperature range (about 5000 K); therefore, daylight film — Kodachrome and Agfachrome — can be used and will achieve the same accurate tones indoors as they do in outdoor conditions.

Tungsten film is balanced at 3200-3400 and can be used in limited types of lighting setups. In daylight, tungsten film develops a blue cast, which is inappropriate for most jobs. It does have its applications, however, for example, in those rare situations when the photographer wants to achieve a moonlight effect without resorting to filters.

Since tungsten lighting is less powerful than strobe, it is necessary to shoot at slower shutter speeds, which limits the movement of the model. Strobe throws out a burst of light that freezes motion up to thousandths of a second, enabling the model to move around with great freedom. A flash system is also much cooler than tungsten, as the latter generates much heat which can become quite uncomfortable for the model.

Despite its power, the strobe unit is extremely portable and can be used in the studio as well as on location. It can be plugged into most household current, whereas tungsten may pull too much power. Strobe power packs are available, and their power ranges are measured in watt-seconds. The units most frequently used in fashion photography range from 800 to 1200 watt-seconds; the more powerful units, 2400 watt-seconds and up, are generally not necessary in fashion and beauty photography and are reserved for those situations which require a strong depth of field, such as product still-lifes.

Lighting Setups. What a photographer does with lighting is very much a matter of personal aesthetic choice, although in some situations a client may have a preference for sidelighting or frontlighting and the photographer may have to deviate from his personal approach. Through experimentation the photographer develops certain tricks that fit in with his style, but it is best to start with a single light source, strobe or tungsten, and work up to more complicated arrangements after getting used to what the equipment can do. Many fashion photographers have found the simplest lighting setups to be best; thus the single light source is quite popular. Portrait photographers use as many as four light sources: a main light, backlight, highlight, and fill light. Light can also be softened by bouncing it off a surface—either a photographer's umbrella, a portable flat, or the walls or ceiling of the studio—rather than aiming it directly at the subject. On the other hand, some fashion photographers use a single direct-light source because the results are more dramatic. It is possible to mix various intensities and orientations of light to create a new ambience. In one session, I set up a powerful strobe behind a Venetian blind so that the light would fall on the model as though it were coming through a window, with a pattern of suggestive shadows. To modify the harshness of the first light, I threw in a softer light from the other side that filled in the light around the model without destroying the effect of the shadows. By experimenting, as in this case, the photographer constantly discovers new combinations, but in most cases it is the simplest arrangements that produce the most satisfying results.

Backgrounds

In studio shooting, simplicity is also the rule for backgrounds. The studio wall can be used as a background; for this reason it should be painted white so that no color is reflected onto the model. But the true, continuous background, the airless space of many fashion photographs in which the model seems to float, is created with seamless paper that is dropped behind and then curved under the model. Rolls of seamless are most commonly 107 inches wide and 12 to 50 yards long. They come in a variety of colors, the most popular being white, black, and various shades of gray, and most photographers keep a selection on hand. The great convenience of seamless is that it is disposable. With each session, a new section can be rolled out and then torn off and thrown out when the shooting is over.

The Studio

It should be apparent that the studio still plays an important role in the photographer's work, despite the fact that location shooting has become far more prevalent in recent years. Much of the most creative work is still done in the studio, partly because of the control the photographer has over lighting, composition, and ambience. And, yet, the studio need not be elaborate. A simple rectangular space with clean white walls and enough room to maneuver and set up lights is all that is necessary for most assignments involving models. The minimum recommended dimensions are 9' × 22', with a ceiling at least 9 feet to allow for shooting and lighting from above.

Since much close-up shooting is done with a long lens, sufficient space is needed to be able to move away from the model. A larger space is usually required by those who specialize in still-life photography. In shooting a series of displays for a catalog, for instance, it is far more efficient to be able to set them up at one time and then move from one to the other. But there is no single, ideal studio setup. In the end, it depends on how much work the photographer does in the studio, the kinds of scenes he shoots there, his equipment and use thereof, and the amount of space in which he feels most comfortable.

Studio Equipment. I have already described most of the basic equipment that goes into a studio: cameras and lenses, lighting equipment, seamless paper, and an umbrella and flats for bouncing light. It is important on any shooting assignment to have backups for the most crucial and delicate pieces of equipment, but especially on location, where the photographer cannot simply go

to a drawer or shelf to get a replacement. It is always wise to have at least two camera bodies ready for use, not only in case of malfunction, but also because it may be necessary to switch quickly from one lens type to another or one film type to another. Other items for which replacements might be needed are light meters, strobe heads, tungsten bulbs, and PC cords.

It was a small piece of equipment, a faulty PC cord, in fact, that created one of the biggest problems I had with nonfunctioning equipment. We had to do the assignment immediately after getting off the plane from another job, and it involved some shooting with a strobe. Even though the equipment was carefully packed and marked "special handling" for the airlines, we found in setting up, that the PC cord, which connects the strobe power pack to the camera body, was not working. Fortunately, I was able to do the natural-light sequences first, but it took my assistant half a day of searching in small camera stores in all the surrounding small towns where we were shooting. He finally came up with the right PC cord and we were able to finish the assignment. There is no guarantee that the backup will work, but at least it provides some insurance and peace of mind in situations where time is of the essence.

Other than the equipment directly associated with shooting, there are several basic items that should be part of most studios. A slide projector is needed for making presentations to prospective clients and for reviewing and editing pictures taken on assignment. A light box also serves the latter purpose. If black-and-white photography is a substantial part of the business, it pays in time and money to have a darkroom in the studio. Prints and contact sheets can then be done to the photographer's specifications and he can get them out immediately when there is a rush. All custom labs have rush service, but it costs more, and there are times when even that is not fast enough.

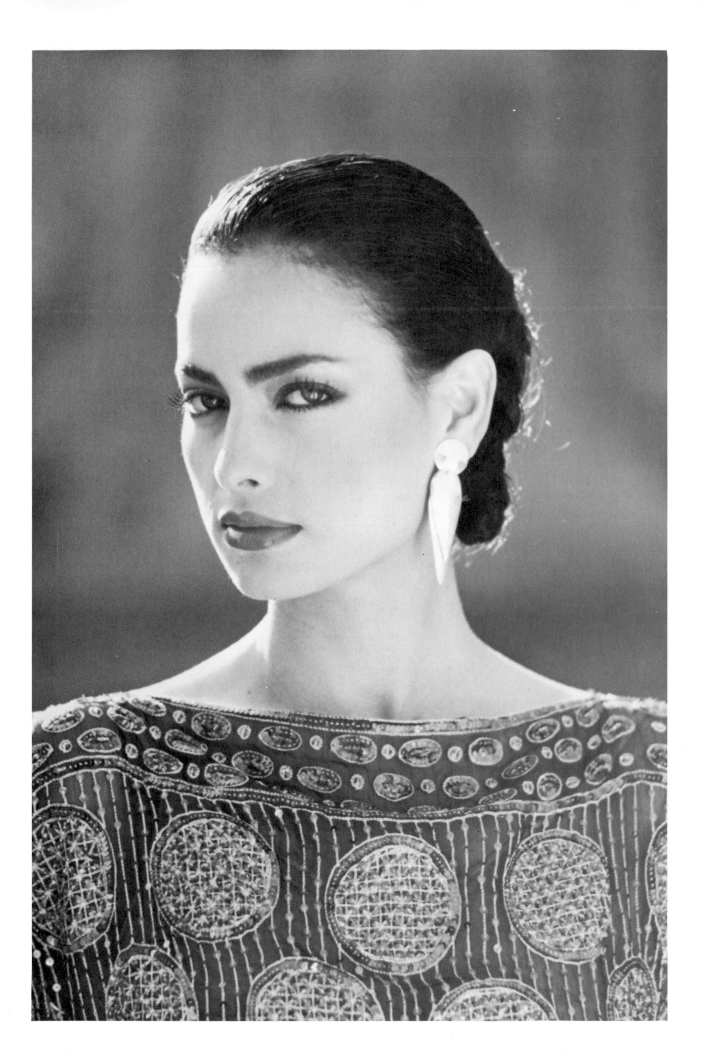

Another important feature of most studios is a dressing room, an area with privacy and enough space for two or three models to dress and be prepared by a makeup artist and hair stylist. This area should have large mirrors, like those used in theatrical dressing rooms, with rows of side- and toplighting that approximate the lighting conditions used for the shooting. Avoid cold, fluorescent light, because it gives a distorted image of how the clothes and makeup will look under studio lights.

Above all, the studio should be comfortable for those who work there—models, stylists, the photographer, and the clients, who often attend shooting sessions. Elaborate recreational facilities are not necessary, but it does help to have some form of diversion or relaxation that will pleasantly occupy the clients during the shooting.

Most propping is done by the stylist or the photographer with the needs of a particular job in mind, but there are certain basic props that may prove useful in the studio. For instance, a stool comes in handy for closeups, because it puts the model at the correct shooting height. Many photographers pick up props—tables, chairs, vases, screens—in flea markets and antique shops for use in their work, and some have accumulated enough props over the years to enable them to rent them out to other photographers. When decorating a studio, it is also useful to keep in mind how the furniture and accessories might be used in some future shooting.

Locations

The studio can become a world in itself, set up to simulate any scene an assignment might require. But because there are so many exotic locations available, it sometimes becomes a choice as to which route to take. A location may be preferable in that, while a studio setting can be made to look real, freedom and naturalness are lost when the photographer and models know it is completely aritifical. If the propping is too costly, takes time to assemble, and involves truckers and messengers, it might be better to get a location. However, it may be impossible to find the proper location, and cheaper still to hire the props and set them up in the studio, rather than rent a location. In shooting pictures for a jewelry catalog, I rented an apartment and got as many uses out of it as possible, creating a restaurant, a library, and a living room in the various rooms. This was an instance where I hired a location to do studio shooting, but it was the most efficient way to handle the complicated logistics of the job.

It is most important that your portfolio show direction and be commercially strong. Once you have achieved that, then you may add an extra creative touch by demonstrating your conceptual ability. These photographs appear in my portfolio for this purpose, even though they are not fashion or beauty pictures. Remember, technical abilities are taken for granted; creative concepts stimulate the art director's interest. (Top left) This photo was done as an illustration to create a renaissance painting scene. (Top right) This photograph of a shooting on a train, taken for Viva *magazine, shows both illustration and propping. (*Viva *magazine. Art Director: Rowan Johnson.) (Bottom) Photo from* Penthouse *magazine shows a stylized illustration, putting props together, and designing the set, which was designed and photographed in the studio. (*Penthouse *magazine. Executive Art Director: Joe Brooks.)*

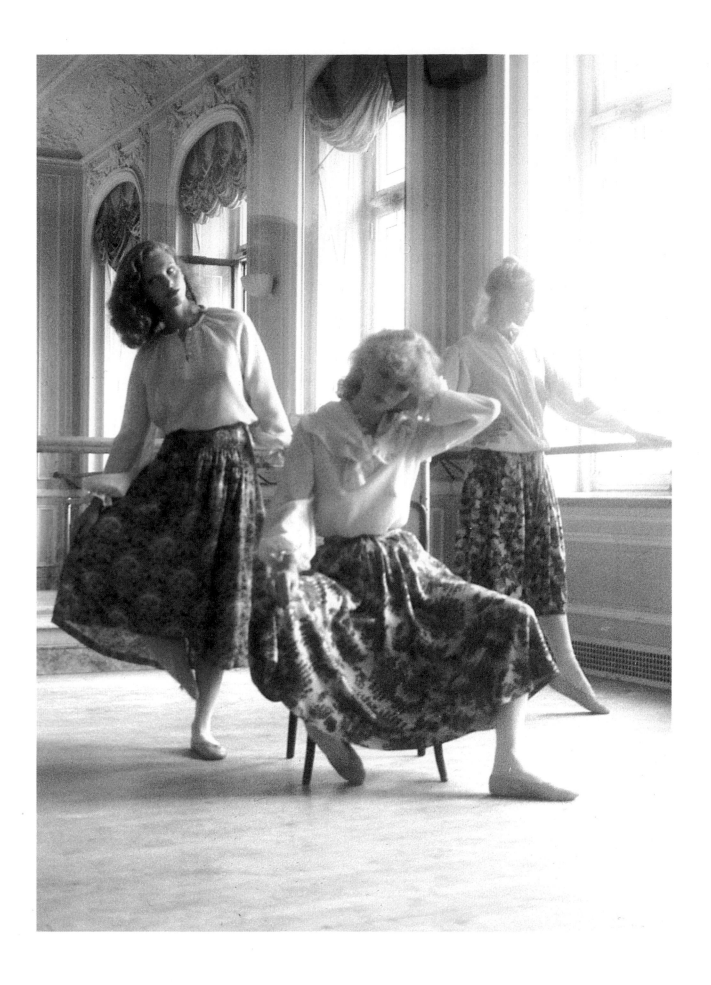

Photographing beauty not only means making a face look beautiful; it sometimes involves more difficult assignments, like this one for Revlon nail polish. The object was to make the hands and nails look beautiful and delicate, as well as durable enough to handle everyday chores, without looking like claws. (Revlon/Grey Advertising. Creative Director: David Leddick. Art Director: David Davidian.)

Choosing the right location to fit the mood the client wants to achieve can make the difference between just another fashion photograph and one that borders on art (left). (Gimbel's. Art Director: Barbara Kaplan.)

Hello?

> *How's the Great American
> Novel going?*

So far it reads more like the turgid insights of a lonely Albanian date-plucker.

> *Did I hear the word "lonely"?*

There's a fog rolling in.

> *You're in Pawgansett, dear. It
> holds the world record for fog.*

The "t" in my typewriter is sticking. I have seventeen cans of lentil soup. And my Paco Rabanne cologne, which I use to lure shy maidens out of the woods, is gone, all gone.

> *You're going to have to do better
> than that.*

All right, I'm lonely. I miss you. I miss your cute little broken nose. I miss the sight of you in bed in the morning, all pink and pearly and surly.

> *And you want me to catch the
> train up.*

Hurry! This thing they call love is about to burst the bounds of decency. And, darling…

> *Yes?*

Bring a bottle of Paco Rabanne, would you? The maidens are getting restless.

> *Swine!*

Paco Rabanne
A cologne for men
What is remembered is up to you

paco rabanne

The Paco Rabanne advertisement on the preceding two pages won four different awards. It is a good example of the way another type of client, in this case a perfume manufacturer, will often hire a fashion photographer not to shoot clothes, but to get an image with the proper "mood."

Here the client wanted a feeling of desolation in a cabin on a lake or by the sea. Originally, they also wanted it to be raining, so we brought along special fire hoses and pumps, as well as a portable generator (there was no electricity in the cabin). However, we couldn't get enough coverage with the water, so we decided to go for the look of mist instead. This was accomplished by shooting early in the morning, exposing for the man under the canopy, and pushing the film in development so that the film emulsion broke up and the highlights became completely washed out. The shooting was very complicated, as we also had to bring along all the props, erect the canopy over the porch, and transport everything to the small, uninhabited island off the coast of Connecticut (Ogilvy & Mather, Inc. Art Director: Alan Sprules.)

One of my favorite editorial assignments was done for Viva magazine. This entire shooting serves as a perfect example of Chapter IV, "Putting the Shooting Together." Except for the theme, which had to be approved by the art director before we started, I was given complete freedom to produce and photograph a fashion layout for resort clothing. After the approval was given, I did not speak with an art director or editor again until I handed in the completed assignment. Accompanying illustrations are some of the chromes that were submitted to the art director. (Viva magazine. Art Director: Rowan Johnson.)

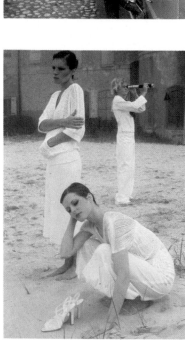

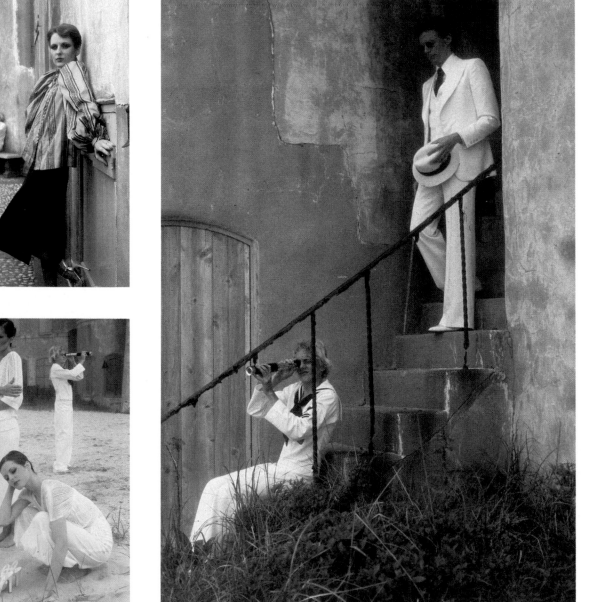

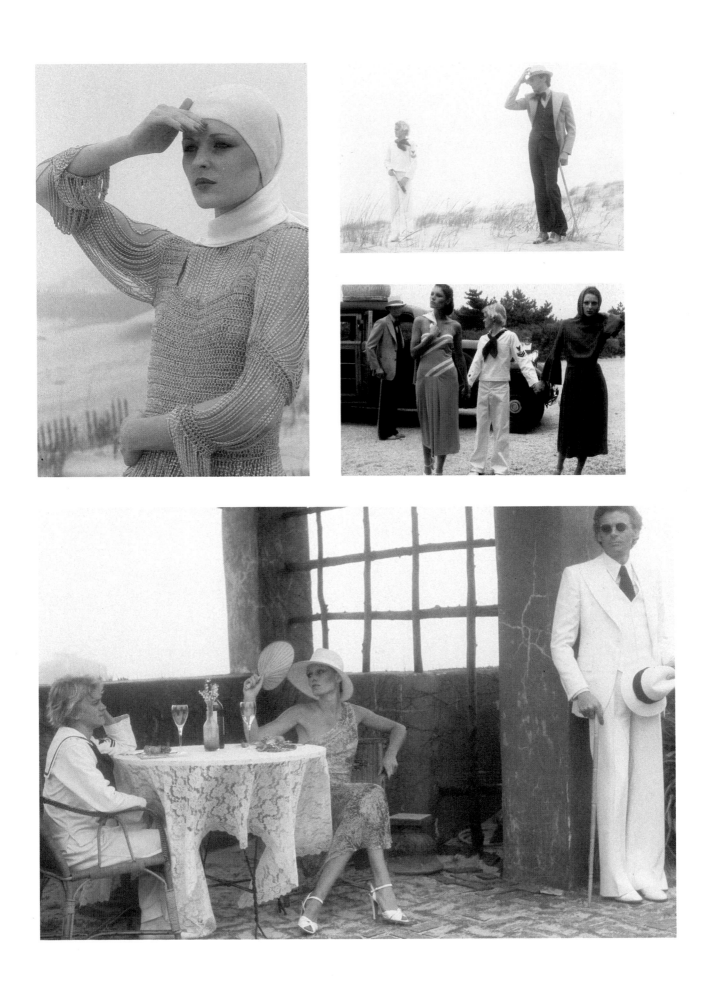

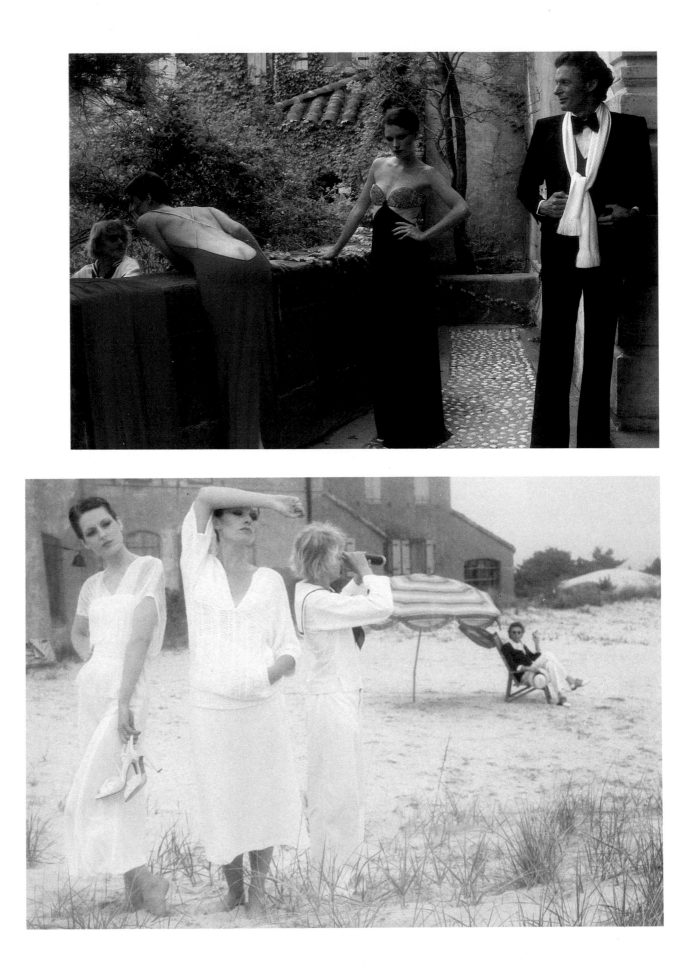

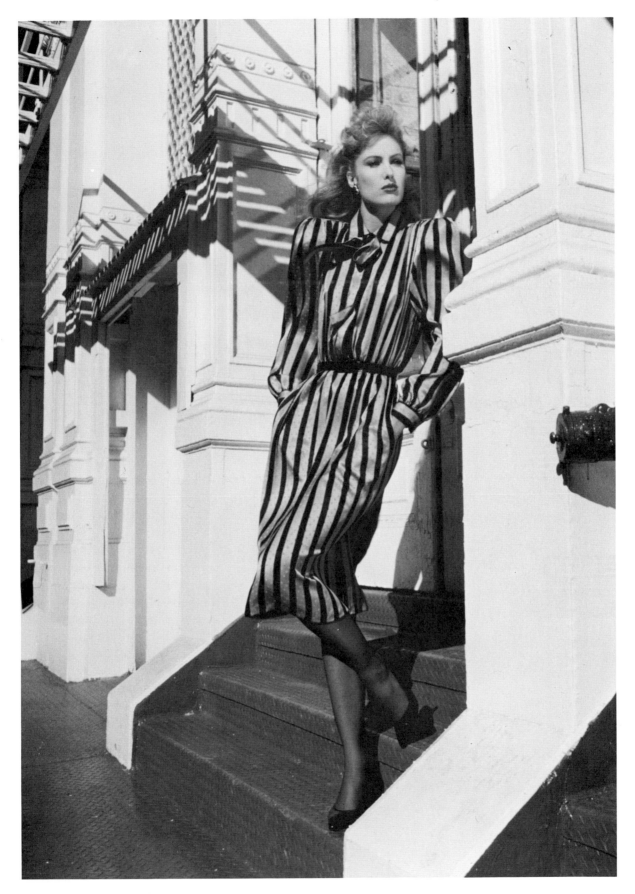

Shooting on location may be preferable to photographing in the studio if you can find the right spot. This location, in New York's fashionable Soho district, works well with this elegant dress. (Saks Fifth Avenue. Creative Director: Leonard Restivo.)

CHAPTER SIX

Putting Together a Portfolio

The measure of a fashion photographer's work is contained in his portfolio. At the beginning of a career, the portfolio is like a novel—a collection of pictures of fictional situations created to express the photographer's own ideas about mood, style, narrative content, composition, lighting, and so forth. Later, it becomes more like a record of his original ideas and their application in actual assignments. Throughout, the portfolio remains a very personal documentation that represents the best a photographer has to offer from all the thought and experimentation he has brought to the medium.

But a portfolio is also a public document—the basis on which art directors, fashion editors, and creative directors determine whether a photographer has the talent and style they can use. For the beginner photographer, it is the means whereby he can gain entrance into the field of fashion photography; for the more experienced professional, it is a reflection of continuing creativity and adaptability to changing styles and new techniques in both photography and fashion.

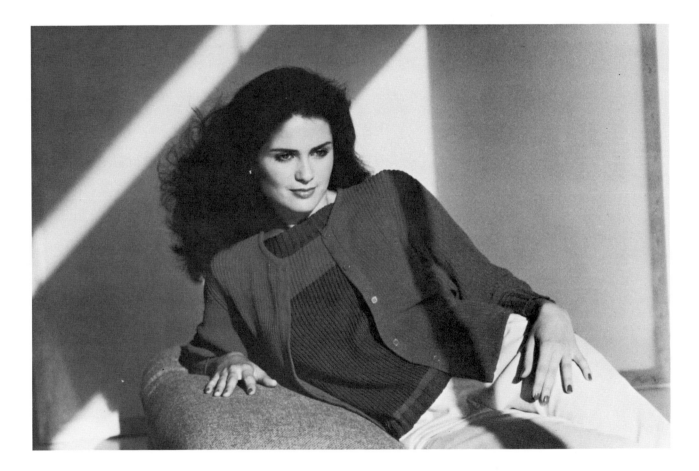

What a portfolio contains and how it is put together is crucial to the success of any photographer at any point in his career. It cannot be thrown together, but must be professionally presented and carefully constructed. Above all, it should present a distinctive group of photographs in an individual style that is not based on technical tricks or ephemeral fads, but has a solid basis in the photographer's own strengths and preferences.

The subject matter is completely different in each of the photographs in this chapter, however, the mood remains the same. This distinctive style is unique to the photographer. It is essential in putting together a good portfolio that the viewer gets the feeling that all the pictures were taken by the same photographer.

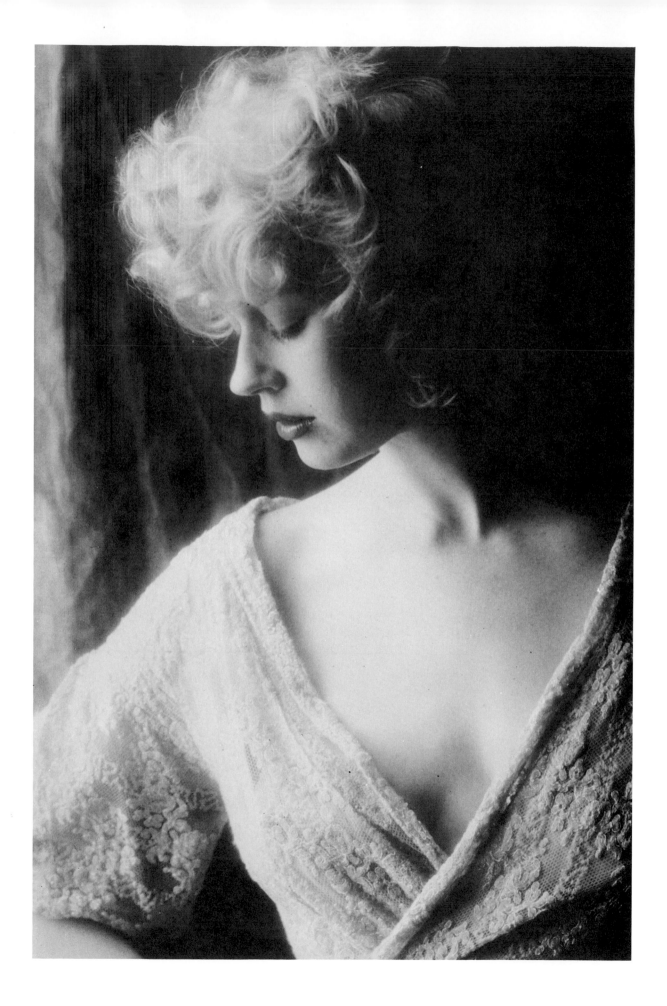

Building a Portfolio

Many photographers entering the fashion field have some experience working with models, locations, and propping either through their training or as assistants to established photographers. But in building a portfolio, everyone begins from scratch, without credit lines, tear sheets, or assignments. This is an advantage, in some ways, since what goes into the portfolio is not subject to the pressures and requirements that affect the shooting of many assignments, but is the result of the photographer's original ideas. With this freedom, it is possible to work more creatively and really show what he can do rather than what a particular job requires.

How can a photographer at this early stage approximate professional work if he doesn't have access to the resources available to the established photographer? Models, stylists, hair stylists, and makeup artists are available on an exchange basis, and many early portfolios are assembled almost completely with test shootings from which everyone involved stands to benefit, and fees are therefore eliminated. Models, for instance, are as dependent on tests as are photographers and will work without fees in order to build their own portfolios. Another mutual benefit of this arrangement is that the photographer is given credit in the model's portfolio and vice versa, so that each gets exposure from the contacts made by the other in his or her rounds of the magazines and ad agencies. In fact, I have gotten several jobs because an art director saw my work in a model's portfolio.

Test Shots. Working with models in this way, a photographer has a unique opportunity to experiment with head shots, full-length shots, and closeups of lips and eyes, as well as different lighting conditions, moods, poses, locations, and compositions. Testing is usually the first extensive experience a photographer has with a model, and he should take full advantage not only to learn how best to work with a model in terms of timing and movement, but also to create as broad a range of pictures as possible, not in terms of style, which should remain distinctive and identifiable throughout, but in terms of the questions an art director might ask himself about the ability of a photographer to work in various situations.

On actual assignments, a photographer may have to sacrifice his ideas for those of the client, but in creating a portfolio, it is neither necessary nor desirable to work on the basis of what he thinks a potential client might want. But this is not to say that a photographer cannot display his versatility in dealing with different conditions and types of shots—with harsh and soft lighting, with movement and stillness, with neutral backgrounds and real settings, with or without some narrative interest, with hard, bright colors and hazy pastels, with or without emotional expression. There are infinite possibilities and the photographer need not give up his style to explore them. A photographer's distinctive style comes through regardless of the situation. An ability to be versatile lends more interest to the work and the portfolio, and, ultimately, inspires greater confidence in the art director who has to judge it.

Experimental Shootings. Test shots of individual models are an important part of any portfolio, but they should be complemented by more elaborate shots that involve several models, different kinds of locations, appropriate propping, and, perhaps, some form of story line or dramatic interplay. For a photographer who has never had an assignment, there is a special value in creating the circumstances that might exist in an actual shooting. This not only enhances a portfolio, but also provides valuable experience in organizing a shooting, dealing with the problems that arise, and working with the people who are involved in such assignments. In putting together a "team"—models, stylist, hair stylist, and makeup artist—for this kind of test shooting, money may be the only thing that is missing, but that problem can be overcome by exchanging services with people who are also in the process of building their portfolios. The models can supply the clothes, and, with ingenuity, props can be borrowed and locations found at no expense to the photographer.

The best way to approach an experimental shooting of this sort, once the team has been organized, is to establish a theme, as though the photographs were going to be used for a particular advertisement or editorial layout. The theme might be a particular product, such as men's shirts, or a whole range of products, such as beachwear or spring fashions. With all the resources and people involved, the photographer should get as much as possible out of these sessions, taking advantage of the location, different kinds of clothes, different moods, and so forth. In some tests, the photographer

could adopt a conservative approach that focuses on the garment or beauty product in a straightforward manner; others could be presented in a more exotic, creative way, perhaps with the idea of creating an entire editorial layout following a story line or at least some sort of thematic continuity. The photographer may include both approaches in one portfolio or set up two portfolios—one commercial, the other creative—to show either an advertising or editorial client the kind of work that might interest him in each case. However, a single portfolio that has a good balance is all that is really necessary, especially when the photographer is just getting started.

In New York and other cities where fashion photography is done on a large or modest scale, it is easy to make arrangements for tests through modeling agencies and the contacts the photographer makes in the profession. But even without these facilities, a photographer living outside the fashion centers can, with imagination, put together a portfolio that will at least give him a start in learning the field. In such locales, the problem confronting the photographer is not studio space, locations, equipment, or even the fashions themselves, but rather the lack of people, especially models, to work with. In such situations, the photographer must develop a sense of the type of looks that will photograph well—people with lithe figures, good bone structure, or something unusual or haunting in their faces, rather than the kind of good looks he remembers from high school. The

This is technically a fashion shot, but it also shows the potential client that the photographer's style can be applied to editorial illustration—or to other products, such as cigarettes.

photographer also may have friends or schoolmates who have a natural talent for modeling even if they have no desire to become models, and whom he could persuade to model for him. It is also a good idea to keep an eye out for potential models in casual situations, but the photographer must bolster their confidence in him by showing them samples of his work and explaining his purpose in wanting to photograph them. With this kind of experience, a photographer can establish a sound basis for the further development of his work and of his portfolio, if and when he moves on to a city such as New York.

Style

A portfolio is not a static document that will stand for all time and all purposes. It is constantly changing, with new photos being added as more tests are made and assignments completed, while others are eliminated. In the beginning, however, it is a matter of finding a direction, of evolving a recognizable style that cannot be mistaken for anyone else's. This does not mean that everything has to look the same, nor does it necessarily lead to specialization in a particular area of fashion or beauty photography. It does mean that the special visual and expressive sense that the photographer brings to the medium should be apparent to the discerning viewer. This may involve a

certain feeling for light, atmosphere, color, line, form, or composition—qualities that ally photography with the art of painting. Some photographers may be more interested in creating unique movements and poses, like a choreographer of ballet or modern dance. Still others may be most adept at getting the most out of the expressiveness in a model's face or gestures. The idea in creating a portfolio is to bring out and emphasize a photographer's strengths and to eliminate and downplay the weaknesses that may exist in order to achieve a special and personal style. A lack of direction or focus in these matters dilutes style in a way that is immediately apparent and inhibits further development. In addition, most art directors in a position to hire photographers want to be confident of the look they are getting, rather than having to guess how a particular assignment might turn out.

In building a portfolio and establishing an aesthetic identity, there is a danger of adopting too limited an approach and being superficial in style. Photography has its fads and fashions, just like fashion, and a photographer can have enormous success if he can exploit them or anticipate what the next rage might be. But he also runs the risk of going out of fashion if that is the only real basis for his work. It is not enough, for instance, to build on a soft, ethereal quality or to follow the nostalgic fad of the seventies and eighties for the kinky, harsh-shadow effects of fashion photography of the twenties and thirties. Exciting work has been done in both modes, but only when subordinated to the distinctive vision of the photographer's own style. Otherwise, the fad becomes more important than the photographer and he becomes typecast in a mold that is difficult to break out of.

Still, it is natural to be influenced by other photographers and important to be aware of both historical and contemporary trends. The paradox of the field of fashion is that the photographer must be in style and above style at the same time. Thus, it requires much study of what is happening and has happened not only in photography, but also in such areas as art, design, even political, sociological, and technological developments that affect the way we experience the world at any given moment in history. These are areas in which our notion of style is anticipated and transformed, as, for instance, the Pop art movement which anticipated the funky fashions of the sixties that succeeded the more conservative look of the fifties.

Applying Expertise

But a photographer should not overdo his research into other areas to the point where he loses sight of his own goals. It is, after all, the way in which he uses the medium that determines the strength and individuality of his style, and this is something that should come naturally with experimentation and an acute awareness of the areas in which one works best. There may be certain kinds of lighting, shadows, poses, and compositions with which a photographer feels comfortable—a way of highlighting features of the face, of relating foreground and background, or of moving a model to create clean, sinuous lines—myriad details that come up in every shooting and sharpen his visual awareness.

In this respect, what a photographer does in other areas is often helpful in his fashion work. My own aesthetic preferences and identity have been formed as much from doing landscapes, still-lifes, and nudes—where there is much greater freedom to

learn and experiment—as from my work in fashion. His expertise in other areas opens up a world of images and possibilities for moods, locations, and props that may not occur to the photographer concentrating solely on his commercial assignments. When I shoot nudes, I often use locations that might also make fabulous fashion locations—deeply wooded areas, rock formations, rooms in old houses, meadows. After having photographed a beautifully textured, cracked old wall, for instance, I can imagine hanging some form of lingerie from a nail in the wall to create an offbeat still-life fashion shot. In the same vein, an ordinary fixture, such as a radiator, might provide an unusual setting for a model leaning against it and putting on nail polish. Working on his own makes it possible for the photographer to consider objects and settings that might otherwise seem outrageous and to see them for their inherent visual and associational qualities.

As a photographer becomes established and successful, his portfolio continually changes. It must be updated periodically to include new material so that clients don't see the same pictures over and over again. Although difficult to do when he has a full schedule of assignments, a photographer should also continue test shooting. This is important because tests permit him to work out ideas without having to consider the needs of a client, and also because the exercise can refreshen his work and prevent it from becoming stale and repetitious. On a personal note, I have retained many of my earliest photos in my portfolio because they still illustrate the purity and impact of my style.

Presenting the Portfolio

The traditional way of presenting a portfolio is in book form, preferably 11″ × 14″, with the prints inserted in loose-leaf acetate or laminated sheets. The pages of the portfolio should be the same size regardless of the size of the print. The expense of good black-and-white and color prints, and of lamination in heavy 40 mill plastic is quite high, but the results can be impressive. The book portfolio provides a direct and convenient way of looking at photographs. It is also a quick way too, unfortunately, and an art director can easily flip through the pages without noticing very much.

For this reason, I prefer slide presentations. If an art director is forced to turn out the lights and concentrate on the photographer's work as it is being flashed on the wall, he becomes a captive audience and is much less likely to be distracted by phone calls and

Tearsheets of published advertisements and printed catalogs are some of the most important and impressive elements of an established photographer's portfolio. They show the potential client that the photographer is not only good, but a professional who knows how to put together a shooting and deliver photographs that work.

colleagues coming into his office. The likelihood of interruption is even less if the presentation takes place in a projection room. In addition to the original chromes that have been shot in tests or on assignments, it is to the photographer's advantage to convert tear sheets and black-and-white prints into slides to be incorporated into the presentation. Slides can be stored in Kodak Carousel trays. It is a good idea to make sure the client knows the photographer will be presenting his work this way, but I have yet to find an ad agency or magazine that doesn't own a Kodak Carousel projector. On the whole, the slide portfolio is easier to put together, cheaper—because it isn't necessary to make expensive prints—and carries greater visual and psychological impact. Still, it is a good idea to keep an updated book portfolio, particularly of tear sheets, and black-and-white prints, to provide for quick review, especially for those who may already be familiar with the photographer's work.

Finally, a portfolio is not only a survey of a photographer's talent, but also a reflection of his attitude toward the work. Care in arranging the material and a neat and attractive presentation are extremely important to clients who want to be sure they are hiring someone who can follow through on every detail of a job. They want to know they are getting a professional in every aspect of the work, and the portfolio is one place the photographer can provide them with that confidence.

CHAPTER SEVEN

Getting Your Foot in the Door

Compiling a portfolio is the first step—a ticket into the world of fashion photography. But even a perfect portfolio, one that shows versatility and brilliant, original photography in a professional presentation, does not guarantee immediate acceptance. A photographer's work does speak for itself, but it may take weeks or even months of interviews and presentations before its voice is heard.

As eager as many art directors may be to discover and encourage new talent, there are many reasons why the process of achieving success is a slow one for a newcomer photographer. One is the fact that there are already tested and experienced photographers with whom the magazines and agencies have working relationships. For an art director to commit himself to an untried photographer requires a certain risk. Even if he is convinced of the talent of a newcomer, it is still safer to go back to the people in whom he has built up a certain confidence. Eventually, after several interviews and the opportunity to become familiar with the photographer's work, an art director may

take the risk, although there is very little in a beginner's portfolio to indicate whether he can successfully accomplish an actual assignment.

The new photographer is also faced with competition from others entering the field—from the numerous portfolios that pass in review before most art directors each week. In addition, no agency or magazine is waiting for the right young photographers to come along to fulfill their assignments. As much potential as an art director might see in a newcomer, it could be some time before the appropriate job comes along in which to test it out.

Promotional pictures are an invaluable tool in helping you get your foot in the door of fashion photography. One of the most impressive promotional pieces are printed, four-color posters. Like calendars, they are often hung on office walls, and provide a constant reminder that that photographer is available for assignments.

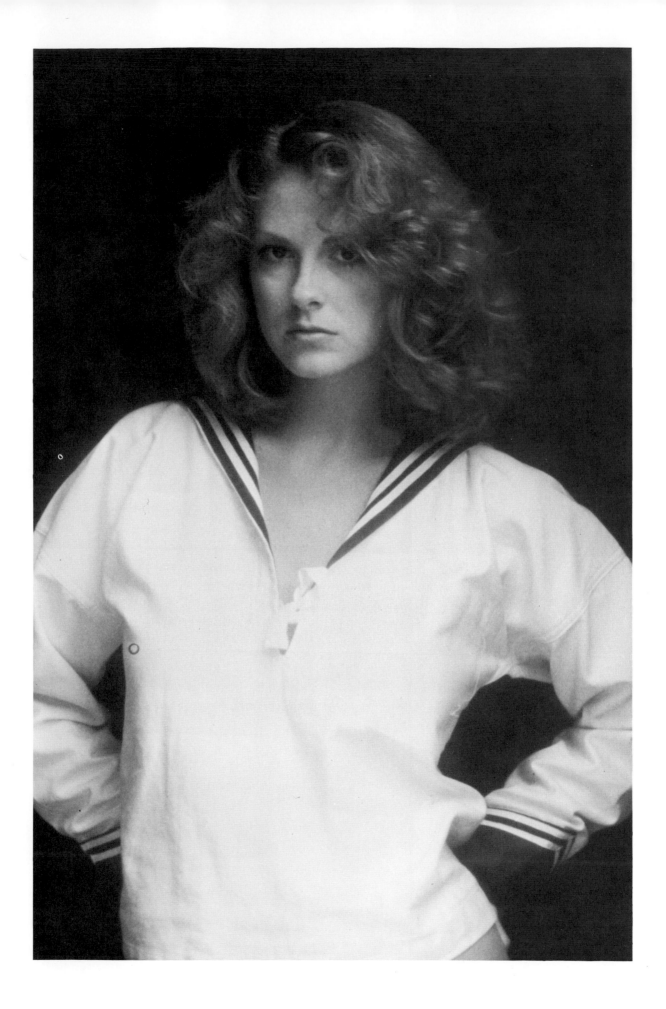

Magazines—the Logical Starting Point

How to deal with the promises and rejections, hopes and disappointments encountered during this initial period of showing one's work is the subject of Chapter Eight. But first, where does one begin? In New York, where most of the advertising agencies and magazines pertaining to fashion are based, the possibilities are overwhelming. The number of art directors and creative directors at advertising agencies handling fashion and beauty accounts alone is enormous; it would take months to keep appointments with all of them. Practically all the fashion magazines and national magazines with fashion sections are located in New York, and those based elsewhere often maintain offices in the city, including many of the European magazines.

The logical place to start is with the magazines. It may not be easier to break in this way, but the road is somewhat less circuitous and more inviting. The photographer doesn't have to deal with the confusing roster of art directors, creative directors, and account executives who inhabit the advertising agencies, each in charge of a different set of clients. In dealing with the magazines, there is only one person to see, at least in the beginning, and that is the art director, whose name the photographer can learn from the masthead of the magazine. Another reason the magazines might be more attractive to a beginner is that they are, in general, receptive to a broader range of ideas and images and therefore are more likely to see the possibilities in a budding photographer's work. An advertising agency is less likely to

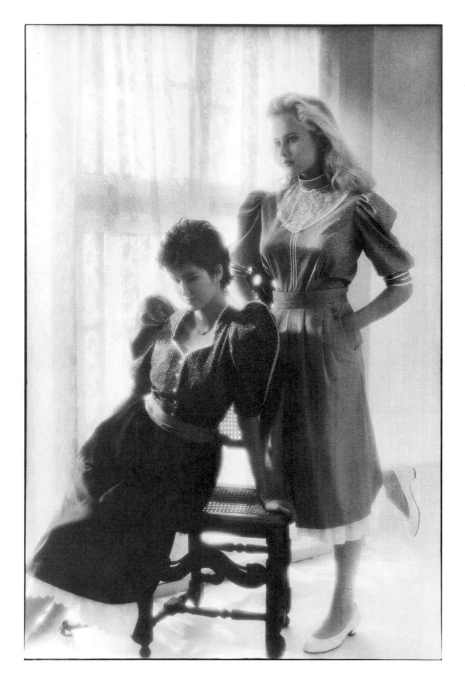

Though this shot was taken in the studio, it has the feeling of being taken in an elegant location. The window was constructed specifically for the shoot. Three strobe heads were placed behind it, and reflectors were used to bounce light back onto the models. In order to get the light, airy tones, I took the light reading with the Minolta III flash meter facing the camera and reflectors.

reach out for originality, preferring to stick to proven formulas, although there are certainly many exceptions. They are also more likely to want proof of a photographer's credentials and are less interested in introducing a new photographic personality and look. Rather, it is the personality and look of the product that counts. A photographer's work is also more quickly disseminated through the editorial pages, where it is readily seen by art directors and usually credited.

Still, if the photographer makes his start with the magazines, he should not neglect the agencies. While it is more likely that editorial work will pave the way for advertising assignments, it is impossible to tell where the break will come. It is a matter of being in the right place at the right time, when something in a photographer's portfolio will spark an idea for a particular ad or story. It sometimes happens that the idea, having been sparked, is then turned over to another photographer, but this risk always exists and is at least an expression of interest.

Cracking the Ad Agencies

The ad agencies are harder to crack and somewhat more confusing at first than the magazines. The larger agencies have a creative director and several art directors, each handling a different number of accounts, as well as account executives and various assistants. A smaller agency may be run by its president and a single art director. All this information, plus the amount of billing an agency does in a year, is contained in the *Standard Directory of Advertising Agencies*, which is published by the National Register Publishing Co. It provides a good place to start in setting up appointments, the only caution being that people change jobs with some frequency in the advertising field, and an art director listed as being in charge of a particular account may have switched to another account or moved to another agency. If there are questions regarding which art directors are handling various accounts, check with the switchboard of the agency beforehand.

The logistical approach a photographer takes in introducing himself in the field varies according to the photographer. A methodical way might be to systematically make appointments with everyone who has anything to do with fashion. However, it makes more sense to focus on areas in which he feels most comfortable. For example, a still-life photographer would obviously go to an art director who might be able to make use of that particular talent. Others might be more adept at working with women's fashions or with beauty shots and would naturally approach those clients first. But, generally speaking, it is in the subtle area of style that one looks for affinities. A photographer naturally associates his own style with that of certain magazines or ads, and, in the beginning at least, it is a good idea to focus on those magazines and products with which there seems to be the greatest possibility of fitting in. This not only increases his chances of success, but also creates a goal about which to feel enthusiastic and hopeful.

In other words, a beginning photographer should consider the direction in which he is going, what his portfolio shows in terms of style—whether it is a slick European look or a commercial American look—and find those magazines which might be most interested in his work. The same holds true in advertising fashion. By becoming aware of the style of photography favored by the manufacturers of various fashion and beauty products, the photographer can then approach those which appear to be most compatible with his own style. The only problem here is that the agency may have no need or desire to hire a new photographer when it already has one or more doing similar work. Still, a photographer gains a certain edge by knowing the preferences of an art director or of a particular campaign.

There are several other indirect methods a photographer can use to enhance his own reputation. If, as is often the case, he has entered the fashion field from another branch of photography—whether fine arts or photojournalism—it may be a good idea to make that work known, even to include some of it in his portfolio. It may peak the interest of an art director and give him a more complete picture of the range of the photographer's style. Any photographer who is able to show his work in a museum or gallery, or to gain exposure in more general photography magazines and books, has a distinct advantage. Many of the most important and influential fashion photographers have also been known, sometimes better known, for their purely aesthetic work. Occasionally, too, the ad agencies will offer gallery space for photographers to show their aesthetic work.

This photograph, converted into black and white from a color slide, has a more European and editorial look than many of my other photos shown in this book. Here the emphasis is heavily on the ambiance—rather than the style of the clothes or make-up.

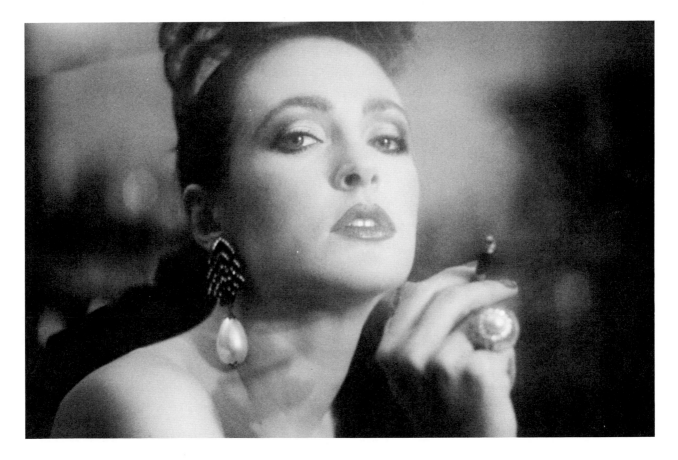

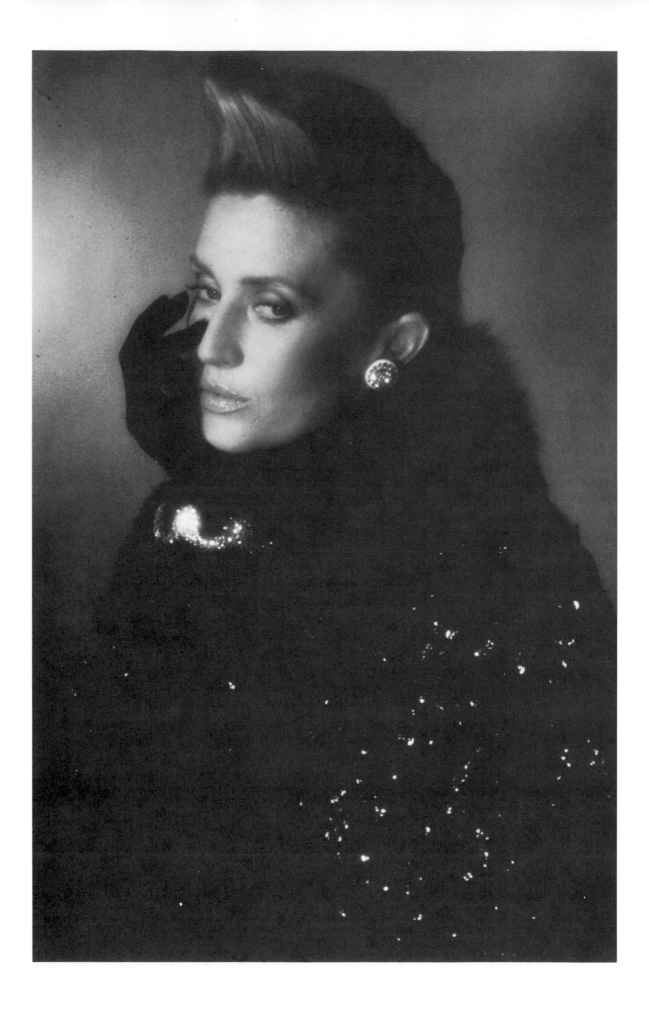

Self-Advertising

At the opposite extreme of this kind of public exposure are the art directors who avoid personal interviews by asking to have portfolios delivered and picked up by the photographer. This can be quite frustrating, not only because there is no reaction, but because it ties up a portfolio for a period of time. The problem can sometimes be circumvented by sending out a mailer, which need not be expensive but should show the photographer's work effectively. This approach may work with some art directors who want to initiate their own contacts. When it seems important to get through to a certain agency or magazine, the photographer should resubmit his portfolio to the art director whenever new material is added, particularly if it is in the style of the client in question. A photographer can also do his own advertising by taking space in fashion or advertising trade publications.

Relationships established with fellow professionals can also play an important role in launching a photographer's career. As noted earlier, working with models, stylists, hair stylists, and makeup artists during tests and in creating a portfolio is a reciprocal arrangement that should benefit everyone involved, and the work that a model shows to an art director may benefit the photographer as well.

Most of the foregoing applies to fashion photography in New York. Breaking in outside of New York may be somewhat different. Cities such as Los Angeles and Chicago have ad agencies, modeling agencies, and fashion manufacturers, though on a much smaller scale. In other, smaller cities, the mainstays are department stores and local companies which, though limited in scope and outlook and lacking in the chance to reach a national level, offer plenty of opportunities for creating newspaper ads, brochures and catalogs. Experience in these circumstances can be a bridge to the more challenging world of New York fashion, or can be an end in itself.

An Ever-Changing Field

The need for the photographer to get his foot in the door does not end simply because he has become established. To rest on assurance of good relations that have been built up with a few steady clients is to stagnate and risk the loss of new and rewarding possibilities. He should set goals and continually pursue them, particularly when he feels that a particular magazine or agency is the right vehicle for his work. But there is also constant change in the field, perhaps more so in fashion, by its very definition, than any other. New art directors, new magazines, new advertisers, and new styles—in clothes and photography—are constantly emerging, not to mention the evolution that occurs in a photographer's own style. In this state of flux, the photographer must keep in touch with developments in the profession and make the effort to introduce and re-introduce himself whenever necessary.

Photographic Representatives

At some point, the demands of a busy shooting schedule and the need to reach out to new clients, or cultivate old ones, come into conflict because of insufficient time and heavy scheduling. It is then that most photographers consider hiring a representative or agent to take part of the burden off their shoulders. This step is not advisable at the very beginning, when it is important that the photographer get a feeling for what is happening in the business, the responses of art directors to his work, the strengths and weaknesses of his portfolio, and the direction he wants to take. Initially, he should go out on his own, get to know the people in the magazines and in the agencies, and establish relationships on a personal basis. This also gives the photographer an idea of how a rep should present his work and the difficulties he will face in dealing with prospective clients.

Once a photographer's business is underway, however, the rep becomes a real asset. He is a salesman and his product is the photographer. He relieves the problems of ego-involvement that arise when the photographer tries to sell himself. Rejection by art directors, for instance, is a personal matter than can be quite unsettling when faced in person. But a rep's feelings are not directly involved, and he can therefore often act more effectively in moving from one client to another. Also, when a photographer is busy, it is good to have someone to take his work around and keep it in front of old and new clients. Even if he isn't busy, having a rep makes it seem so. It is a sign of success.

A major consideration in choosing a rep is that he know the field, who to see, the pricing structure, and how to get the most out of budgets and credit lines. Having someone to handle the business end frees the photographer to concentrate on his creative work rather than spending his time on interviews, negotiations, finances, and even billing. Since a rep implies prestige, he can also often get higher fees. Being more objective than the photographer, he can be more independent and demand more of the client.

It is important to get the right person, someone who is enthusiastic about the work he represents and will spend time on it. Even the top reps in the business won't do any good if this isn't true. Some reps may not have the right contacts for a certain kind of work. There are those, for instance, who are associated with a straight commercial look and would not be in a position to sell a slick, European look. If he represents more than one photographer, the rep should not take on more than he can handle, with the danger of someone getting lost in the shuffle or competing with the other photographers he represents. On the other hand, it is not necessarily advantageous to have a rep whose sole income comes from one photographer, unless the latter is in a position to make him a partner and turn over the entire business side to him. Above all, the rep has to be a true reflection of the photographer himself. They should have a good working relationship as well as complete confidence in the ability of the other.

Fees. Reps' fees fluctuate according to the kind and amount of work they do. The standard fee might be 25 percent of what the photographer gets from a client, although some might charge only 20 percent for an editorial client and 30 percent for an advertising client or an out-of-town job that has taken more time, effort, and expense to get. In the beginning, the arrangement may be that he gets a percentage only on the work he develops, until such time as he becomes basically responsible for the photographer's career and the direction it is taking. But, as most photographers who have been through it know, it can take a long time for a rep who is starting out fresh to acquire accounts. Since he usually covers his own expenses, it may be wise to give him a small percentage of the house accounts.

Later, the rep may be responsible for every aspect of the business operation, relieving the photographer from any involvement in sending out bills, collecting money, paying taxes, bookkeeping, and negotiating contracts, as well as showing the work, getting new clients, and keeping old ones. He then becomes a partner with an interest in the overall business. But his percentage is more than paid for by the savings in time for the photographer and the greater influx of work.

Maintaining Contacts

Still, the photographer should maintain his personal contacts with clients. This is especially true with the magazines, which, on the whole, would rather work directly with the photographer because the approach is generally more creative and can't be done secondhand. The rep is likely to be more effective with the ad agencies, because they have less need of the photographer's participation in working out ideas. The interlocking of efforts between rep and photographer requires constant, daily contact if it is to be a working relationship, so that each knows what the other is doing at all times. Ideally, confidence will develop to the point where all negotiations can be turned over to the rep, even when the initial contact is made through the photographer.

Annual Report

REVLON

This photo was originally rejected from Revlon, but retained in my files. One year later, the graphic designer of Revlon Annual Report noticed it and repurchased it for his cover. (Revlon, Inc. Creative Director: Martin Stevens.)

Stock Photo Agencies

Another form of representation is the stock photo house, which offers benefits beyond those connected with assignments from agencies and magazines. Over the years, most photographers accumulate pictures—fashion photos as well as landscapes, nudes, still-lifes, or other subjects—that may have value as stock photos. These can be placed with a stock agency, which in turn will try to sell them to ad agencies, magazines, or other publishers who don't want to go to the trouble or expense of setting up an original shooting. Usually they will pay the stock house what the photographer would normally get for an assignment, because the picture is exactly what they are looking for and they are still avoiding the expenses of film processing, stylist's fees, location fees, and so forth. The stock agency takes a 50 percent commission, which seems high but is not when you consider that no extra work has been done and the picture would otherwise be sitting in a file.

The astute photographer can obtain many additional stock photos by taking advantage of the opportunities offered by actual assignments and coming up with other angles for shots not included in a particular job. At such times, he should have the models sign releases, with the explanation that the picture might later be sold through a stock agency, and that the model would be paid for an hour's work when the picture was sold. Stock houses also provide extra exposure for photographers that sometimes leads to jobs. For this reason, it is wise to sign with an agency that promotes the work of individual photographers in addition to the subject categories.

From interviews to photo exhibitions to stock agencies, what the fashion photographer is doing in his early efforts, by tapping all the possible outlets, is becoming familiar with the structure of the field and finding out how best to fit into it. As he gathers more knowledge, in terms of how agencies and magazines are set up, the people who run them, and what they expect, his initiation becomes a dialogue through which his work and goals are refined. The waters can be tricky in this respect, but in the end, if his image is strong and capable of development and his determination tempered by openness to change, he will be rewarded with more than a foot in the door.

Sometimes impulse and spontaneity create the best images. This photograph was taken while waiting for the van to arrive and pick up the crew of an on-location, commercial shooting. The hair stylist, Hari Von Wijnberge, started playing by putting a veil on the model. I picked up my camera and photographed the model against the sky with a Minolta 100 mm lens and Agfa 200 ASA film. The richness of the sky was enhanced by a polarizing filter.

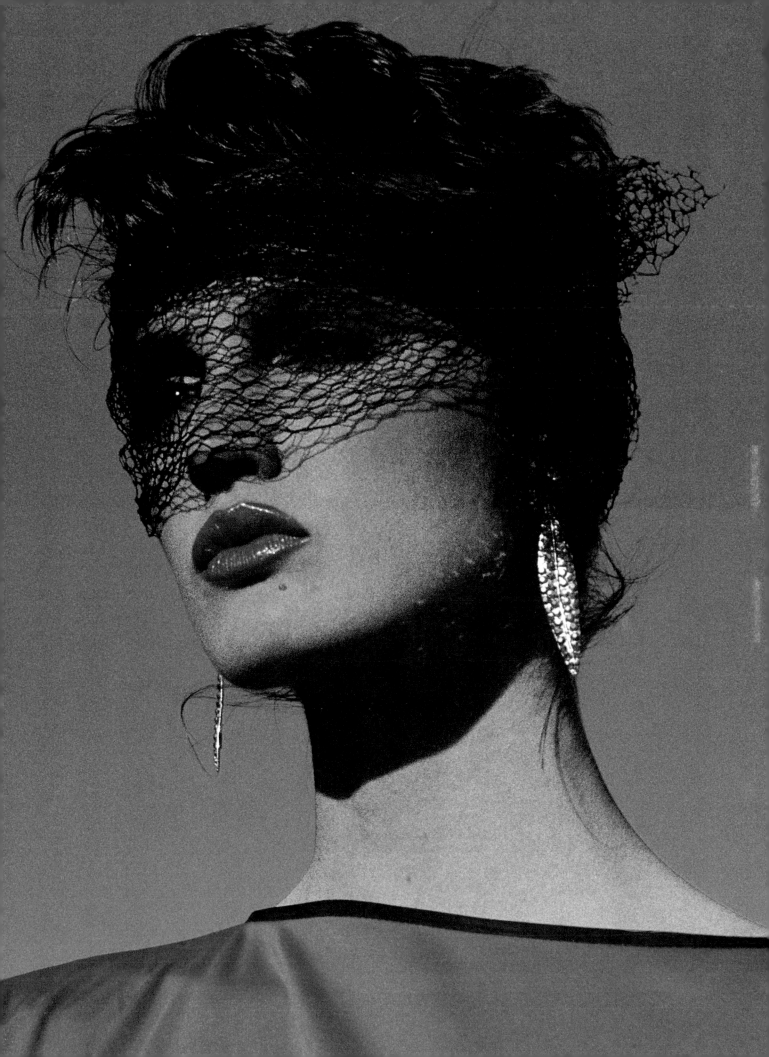

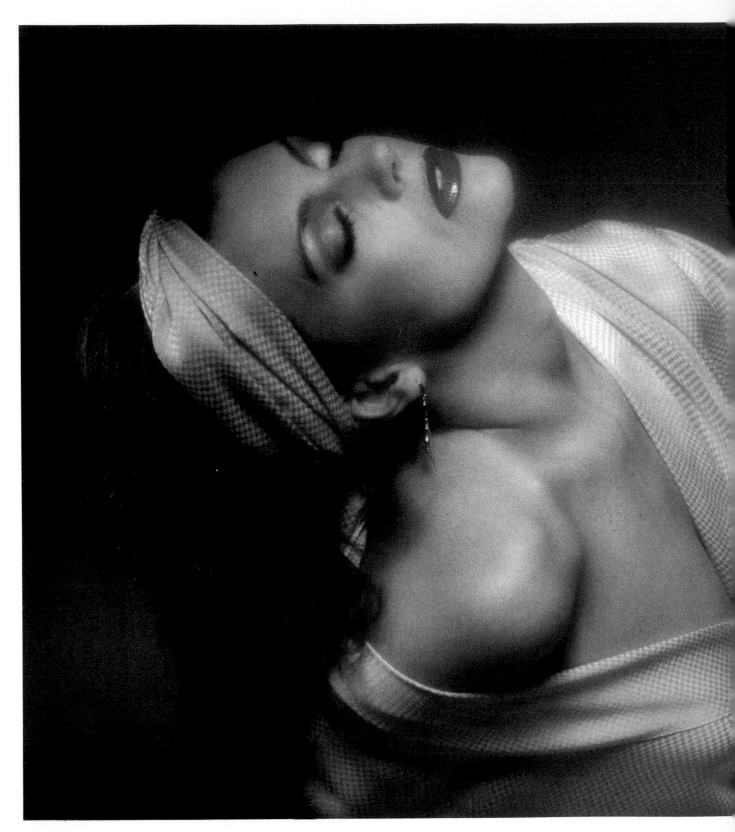

This image, taken with Agfachrome 200 ASA, was done in the studio. The model was lit by one strobe head fitted with a Balcar Soft Box and directional grid. The film was pushed one stop, to 400 ASA, in development.

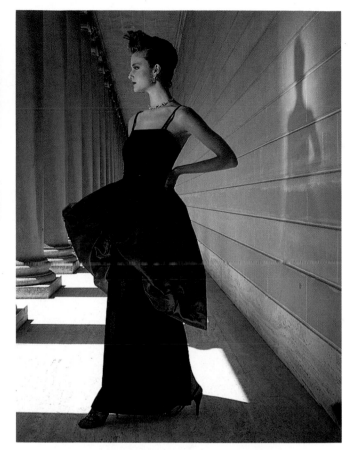

For the top right shot I worked with the graphics of the "Legend of Honor" in San Francisco. The shadow on the wall, and the light on the model's face, was cast by an assistant with a gold reflector positioned in front of the model.

This "still life" of shoes was shot on a set built in my studio. The light coming through the latticework window is actually electronic strobe with filters to make it simulate the warmth of late afternoon sunlight.

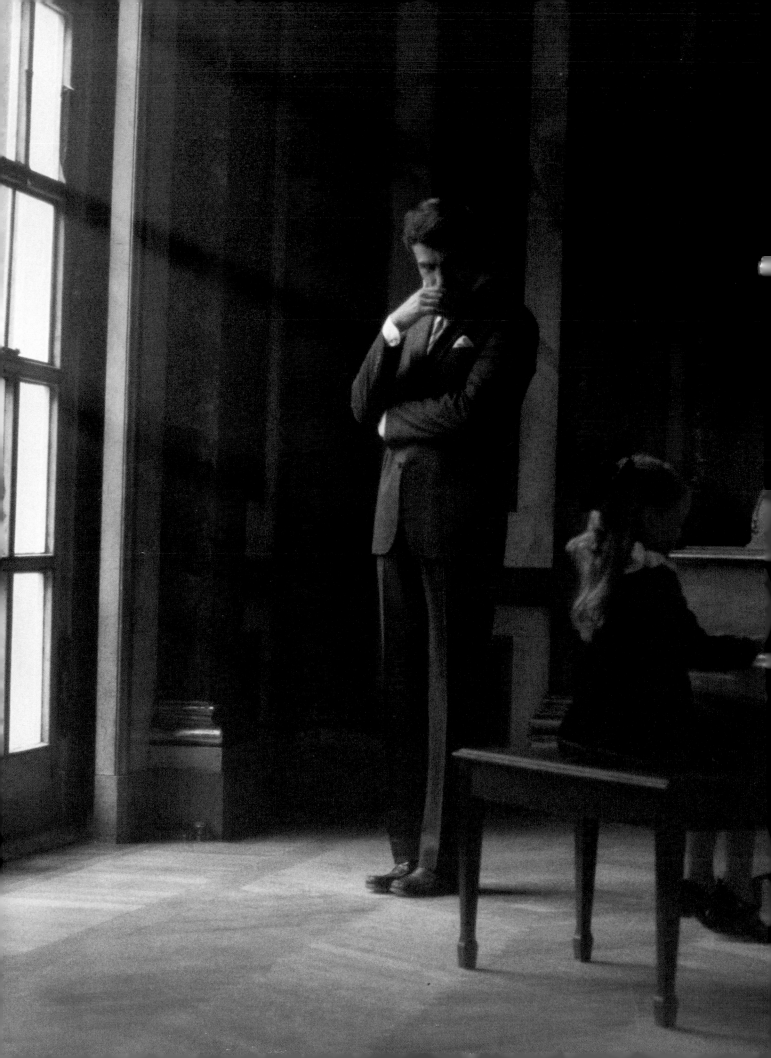

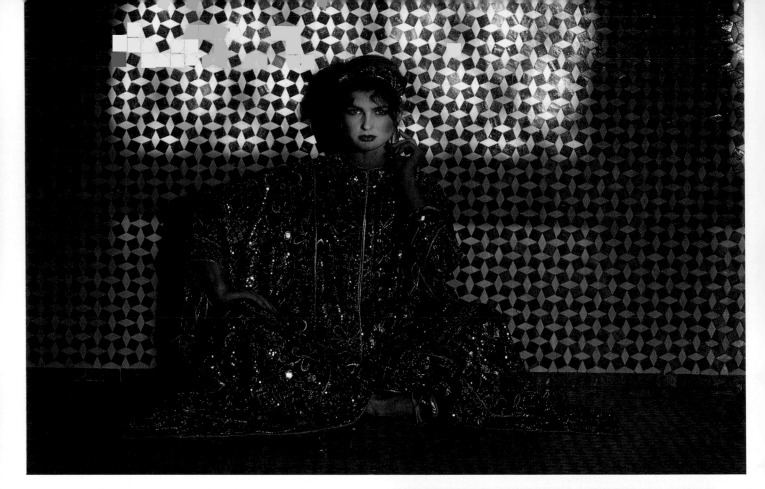

For this shot above, taken on location in North Africa, we had to work quickly because of the rapidly changing late afternoon sunlight. The model started by standing in front of the wall, but as the sun went down she sat. The pictures of her seated, with the direct light highlighting just her face, proved to be much more effective.

This image on the right shows how a good professional model can impart a feeling of attitude and movement to a fashion photograph. Taken in front of the Customs House in New York City, it was lit only with available sunlight, but reflectors were used to highlight the model's face and the statue.

The photograph on the opposite page was taken after the shooting for a dress advertisement was finished. I saw something in the location that excited me, but I knew the client wouldn't go for it, so I worked with the model for one extra roll of film. I put her out of the center of the frame to add some tension to the composition and had an assistant reflect the light from a small round mirror onto her face.

The advertisement on the preceding pages, taken to promote Hart Schaffner & Marx suits, was a situation where the client gave me total creative freedom to do whatever I wanted. The only information he provided was that the headline for the ad would read "The quality of life". It was taken on location, with natural light, and with the film pushed two stops in development.

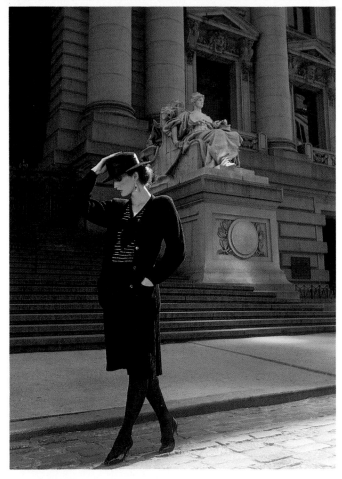

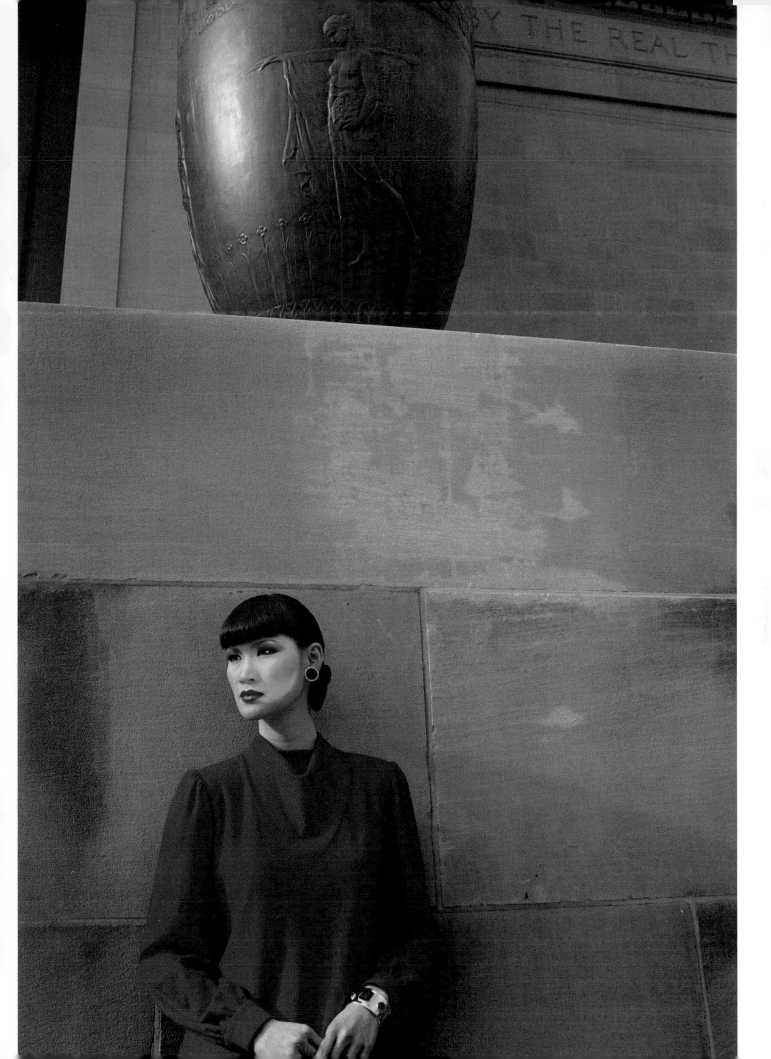

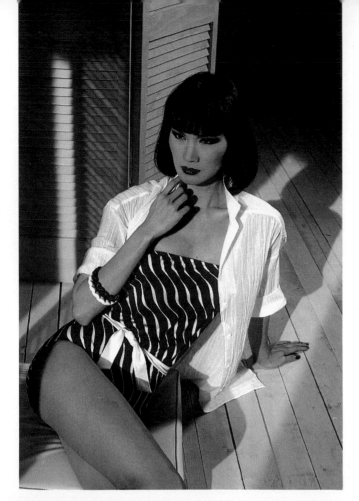

This picture, taken on a set built in my studio, was lit primarily by direct sunlight coming through a window. However, I used a strobe for weak fill light to ensure that the background did not go entirely black. I also used an 81A filter to add a slightly warm tone to the image. (J. Cox Advertising, Ivey's. Art Directors: Marshall Sudderth/Roger Busby.)

For this shot, taken in the lobby of the World Trade Center in New York, I worked with the direct sunlight coming through the windows and the exciting patterns it created. (Saks Fifth Avenue. Art Director: Linda Burney.)

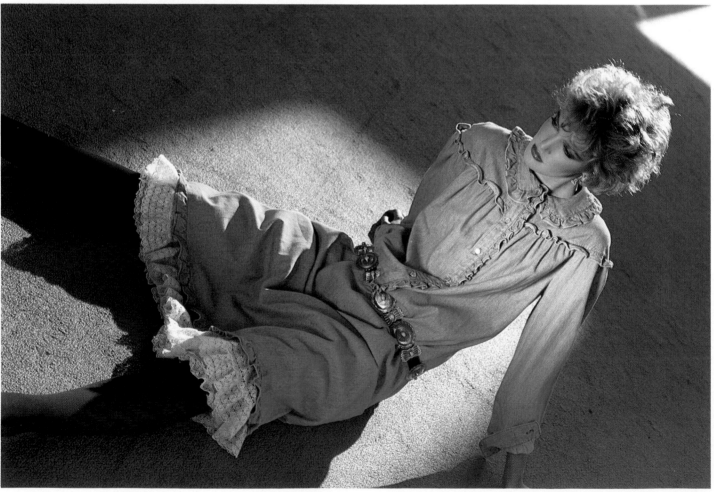

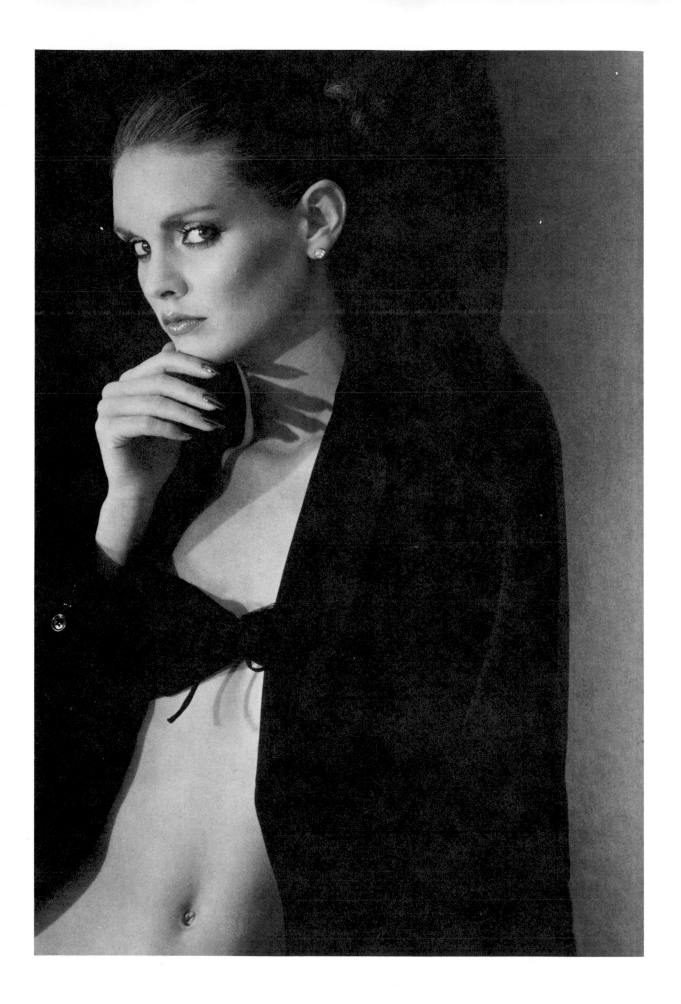

CHAPTER EIGHT

Psychology

When a photographer walks into an art director's office for the first time, he has no way of knowing what the reaction will be. While it is possible to determine generally the style a magazine or particular ad account prefers, and whether one's work fits into that style, there are a variety of factors, practical and psychological, that will affect how it is received. It is important to remember that an initial reaction, whether favorable or unfavorable, is not a final decision. He may encounter enthusiasm or criticism, but rarely does a photographer walk out of a first interview with a purchase order in hand. This initial contact serves as an opportunity to present the work, to get to know the personalities and procedures of individual art directors, and to learn how best to proceed in terms of the strengths and shortcomings of the portfolio itself and the amount of persistence to devote to pursuing a potential client.

Psychologically, the initial period of interviews is a challenging time in a fashion photographer's career. He is subject to the ups of promises, the downs of rejection, and the gray middleground of noncommitment, and he must learn to deal with each and continue with patience, ingenuity, and confidence in his work. The idea is not to become a super salesman, but to rely upon and stand behind the integrity of the work. There is no foolproof system of tactics with which a photographer can convince an art director to hire him. It is the work itself that counts and the conviction and enthusiasm the photographer brings to it.

Most art directors are noncommittal when they see a portfolio for the first time. They may ask questions about individual pictures, about models or locations, but never reveal their opinion about the work as a whole. The tendency of the photographer is a desire to overtalk, to get some reaction, to describe with words the impression not conveyed by the photos. The art director, however, is not there to offer a critique of the work, but to judge for himself whether he might be able to make use of the photographer's talents in the future. From the start, the relationship is a professional one in which the art director has no obligation to offer advice, and the photographer cannot really seek it; it is neither the time nor the place. He is there to push his work into view, not to look for guidance.

Still, there is a lot to be learned by observing and listening carefully to the comments the art director makes. The photographer is presenting a certain image, and the art director is looking for a certain image. If the two coincide, the photographer's chances are much better. If they diverge, there may still be something in the work that leads the art director to think in positive terms about it. This doesn't mean that the photographer should rush out and change his portfolio, to force his work into an image he thinks will suit the client. The integrity of a photographer's style should be guarded and promoted, but he should also be aware of those aspects of the work to which there is the most favorable reaction, no matter how subtle. It is then possible in future interviews to present work, without making basic changes in his style, that is more appropriate to the particular client.

The photographer also has an advantage if he can make suggestions about how his work and approach might be applied to a certain product, without pushing the possibilities where there are none. Art directors often look for ideas that might apply directly to an upcoming job, and a new portfolio might spark them. If a director sees something he can use, he might be more willing to consider hiring a new photographer. But again, it is especially important in a situation like this to follow up the initial interview with additional material, to see the art director again and keep the work in front of him, always remembering that he may still go to another, more familiar photographer to accomplish the ideas he derived from your work.

Art Directors

The length of an interview doesn't necessarily indicate acceptance or rejection. Some art directors take the minimum amount of time, staying only as long as it takes to go through the slides in a Carousel or the pages in a book. The director may be in a bad mood or feeling the pressures of his work. There may be many distractions, or he may be seeing many photographers. He may have a quick eye and not need extra time to consider every shot, or, quite frankly, he may not like the work. Other art directors are more leisurely. They comment on or want to know about each picture and offer information on how and where the work might fit in. For the photographer, unless there is a genuine rapport from the beginning, it is best to keep comments to a minimum, to answer questions with enthusiasm and perhaps inject facts that may not be evident in the pictures themselves—not so much about what he was trying to achieve with the picture (that should be apparent), but who it was shot for and where it ran. There is a fine line in selling oneself—in pushing oneself as a product—so the presentation should not sound too egocentric. The work should speak for itself. Since photographers are essentially visual people—as are most art directors—who are constantly creating and composing scenes in their minds, that is where the excitement lies and how it should be conveyed, through the pictures themselves.

Occasionally, one has to be prepared for the art director who tears a portfolio apart if he doesn't like it. He may be critical about every shot, making invidious comparisons with the work of other photographers, or he may say, as one art director did to me at the start of my career: "I've seen these things before. . . . What's so unusual about them?" There is really no remedy for this kind of attack, but neither should it be cause for disappointment or discouragement. Such reactions are few and far between, and they simply have to be weathered and forgotten before moving on to the next appointment.

On the other hand, there are those who, as soon as they see a new portfolio, start fitting the photographer into this job and that, making promises that have a very slim chance of being kept. I have been around the world many times on such promises, visiting the most exotic places on jobs that never materialized. Of course, what the photographer does learn is that such jobs do exist, suggesting possibilities for the future. But no job should be counted as secure until it has been billed. Promises are also a problem when the art director who has made them moves on to another job. Since the new art director is not obligated to follow his predecessor's choices, the photographer may be left in a lurch.

There are, however, more concrete signs of interest and approval. If the photographer is shown some of the projects being planned by the magazine or agency, this may indicate a serious interest in his work, if not for immediate use, then for future consideration. A good impression may also result in the art director calling in colleagues—a creative director, editor, or account executive—to see the work. Both of these circumstances raise a photographer's expectations, but he shouldn't allow them to go too high. The encouragement is refreshing, but the goal is to be hired.

In the beginning, the photographer concentrates on seeing again and again as many potential clients as possible, getting his name around, and narrowing the field to those who seem to be most interested. After a while, if he is successful, the process begins to accelerate and reverse itself. Art directors, getting to know his work either through his portfolio or jobs that have begun to come in, may ask to see his portfolio again in connection with a particular job.

This does not automatically mean that a job is assured. In all likelihood, several other portfolios have been called in at the same time and there is probably more chance of being rejected in favor of the competition than of being accepted. Even when a portfolio has the approval of several people in an agency or magazine, it still runs the risk of being vetoed by someone who doesn't care for it. But to be considered in this way is at least a step in the right direction.

Photographer/Art Director Relationship

Despite the fact that the relationship between an art director and a photographer should be maintained on a professional level, there is also a personal side which sometimes determines whether a professional relationship is possible and how the photographer should proceed. There may be rapport or awkwardness, although the latter should not undermine the value of the work. But there are also more subtle factors of personality that the photographer has to take into consideration when determining how to present himself and his work. Aggressiveness may impress some art directors and offend others. When it comes to socializing, it may do more damage than good to go beyond a business relationship with someone with whom the photographer doesn't have that much in common. Falseness takes over and the chances of working with the person on a professional level may suffer for it.

Landing a Job

It must be remembered in the early stages than an art director is under no compunction to offer an assignment to a new photographer. He already has photographers with whom he has worked and feels secure, and a photographer without a track record is somewhat at the mercy of the market. It may, therefore, come as a disappointment if the first job offered is not as distinguished or does not pay the top rates he had expected. It is usually to the beginner's advantage to accept a job, even though it doesn't pay well or stir his imagination. The client is, after all, taking a chance, and the photographer is gaining experience and something to put in his portfolio. It also gives a boost to self-confidence, which might subtly be eroded if the job were not accepted. A photographer can also look at it as a blessing in disguise, in that valuable experience is obtained without having to face the complexities of a major shooting involving lots of money.

After all that a photographer goes through to establish himself, the challenge of trying to get a job and the excitement of landing it can be as rewarding as seeing the final pictures. Because of this, there is often a letdown after achieving this initial goal, knowing that the job now has to be organized. But once work begins with the art director and it becomes clear what has to be done in terms of finding a stylist, models, locations, and so forth, a new kind of excitement about the job begins to build. Fashion photography is a series of hills and valleys in which periods of accomplishment and exhilaration are interspersed with periods of drudgery. This is why it is important to keep a level of enthusiasm for each new job, both to let the client know that it is appreciated and to maintain a continuity from one peak to the next. No matter how many jobs a photographer does for the same client, or how many similar setups, there is always something new to be learned or tried, and it should be remembered that the hard work that goes into any shooting is even more transitory than the final accomplishment of it, which, at least, is recorded in print.

Probably the ideal attitude to develop during this early period of interviewing and promoting oneself is a balance between optimism and healthy skepticism. The key is persistence—to keep after those clients who seem to respond, and to constantly present them with new alternatives in one's work. A photographer must be prepared to show his work on short notice and to meet with the most critical people, and to know that in the end the tide can be turned in a favorable direction. Without becoming over-aggressive or overconfident, his approach from the first interview onward should be positive. While being wary of promises and rejections, the photographer must establish his own goals and maintain the attitude that, if the clients are right for him, he will someday be working for them.

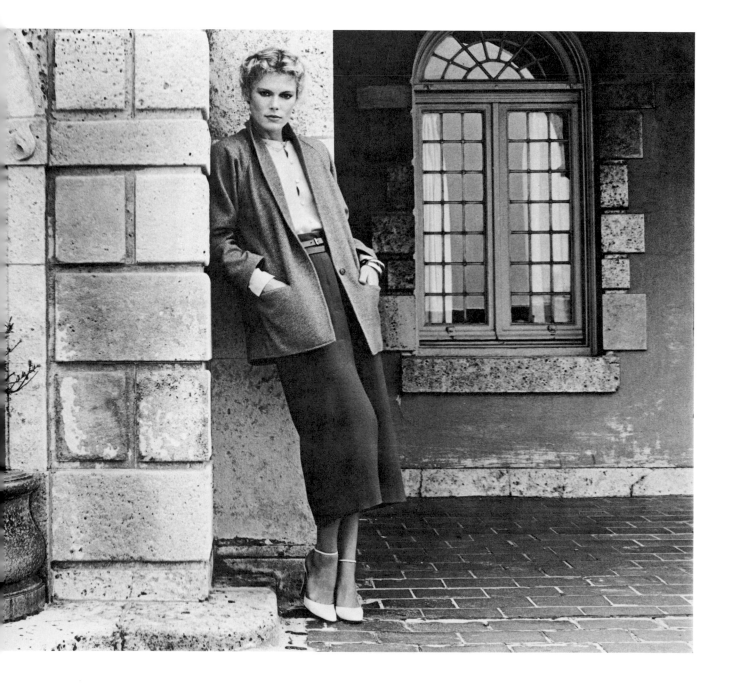

CHAPTER NINE

The Finished Product

When a photographer takes his first assignment, there is still a lot that he doesn't know, or, at least, a lot he feels he doesn't know, no matter how many tests he has been through. Likewise, the responsibility of a major job—knowing that there is a large fee involved and a lot of money, time, and effort being spent on models, hair stylists, makeup artists, locations, and other necessities—is, in a word, stimulating. A photographer cannot easily imagine what the experience will be like until it happens.

The motivation is excitement and, perhaps, fear—fear that, with all those people and resources gathered around him, the whole thing could come tumbling down on his head. A fear that something will backfire: the models won't respond, there will be a malfunction in the equipment, or the exposures will all be wrong. The result of which is that he does much more than is normally necessary. On my first major job, I "bracketed" every shot. I didn't know whether I was expected to shoot a lot of film or

a little, so I overdid it. There is also the fear of looking silly, as though one doesn't know what he's doing in front of people who have more experience. But the photographer has to overlook such feelings and be as cautious as he thinks he has to be, without worrying about what others might think. With experience comes confidence, and out of that a more certain knowledge of when a shot is right. Overcaution becomes unnecessary as the photographer develops a working method of his own.

Film Processing

The end of a shooting is not the end of the assignment. The film still has to be processed, edited, printed (if black-and-white), and presented to the client for final selection. While there is little that the photographer can do at this point about how the pictures turn out, it is no time to let down. Most professional labs in the large urban centers are fast and reliable, but it is wise to get to know a particular processor and their capabilities. If there are mechanical failures and the film is ruined or badly processed, it is the photographer's responsibility, and a re-shoot may be required or, at the very least, the client will be left with a poor impression. If a job is needed quickly, it may be best to use Ektachrome film, which only takes a few hours to process, whereas Kodachrome must be sent to the local Kodak lab and may take a day or more.

Black-and-Whites. Working with black-and-white films is more time-consuming and complicated, and the final product, the print, depends to a greater degree on what happens in the darkroom. This involves making contact sheets, then working prints of those selected by the art director, and, finally, finished prints of the pictures to be used, which are usually 11″ × 14″. All this can be done by an outside lab or someone the client selects, but under deadline pressure, it is often necessary to ask for rush service, which costs twice the normal rate. Many photographers prefer to have their own darkroom, particularly when they are engaged in a lot of black-and-white work. It can save time and give the photographer control over the kinds of effects he wants to achieve in his prints. In addition, the client is saved some processing fees, and the money that would have gone to a lab reverts to the photographer.

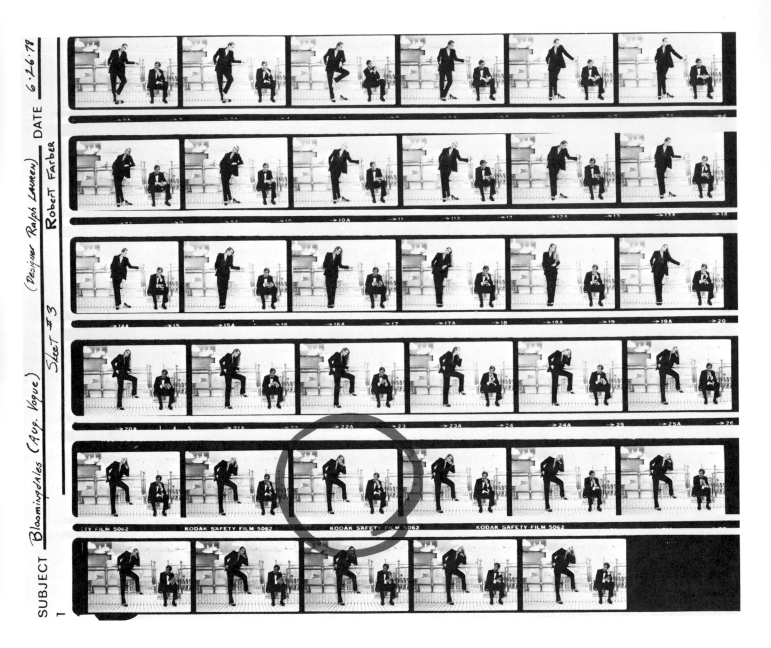

SUBJECT __Bloomingdales (Aug. Vogue)__ Sheet #3 __(Designer Ralph Lauren)__ Robert Farber DATE 6.26.78

Editing

Before any work is presented to the client, the photographer screens the pictures and does a rough editing, cutting out any bad exposures and shots that obviously don't fill the bill. (This is not possible when contact sheets are involved.) As much as he is tempted to at times, the photographer should not let his preferences affect his editing and elimination of shots. The art director wants to see what he asked for, even though in the end he may choose the photographer's version, and he should have the choice, even of bracketed shots, when one might serve as well as the other.

*This was the choice the client made based
upon the contact sheet. We were both
pleased with the decision. (Bloomingdales.
Art Director: Raina Domevich.)*

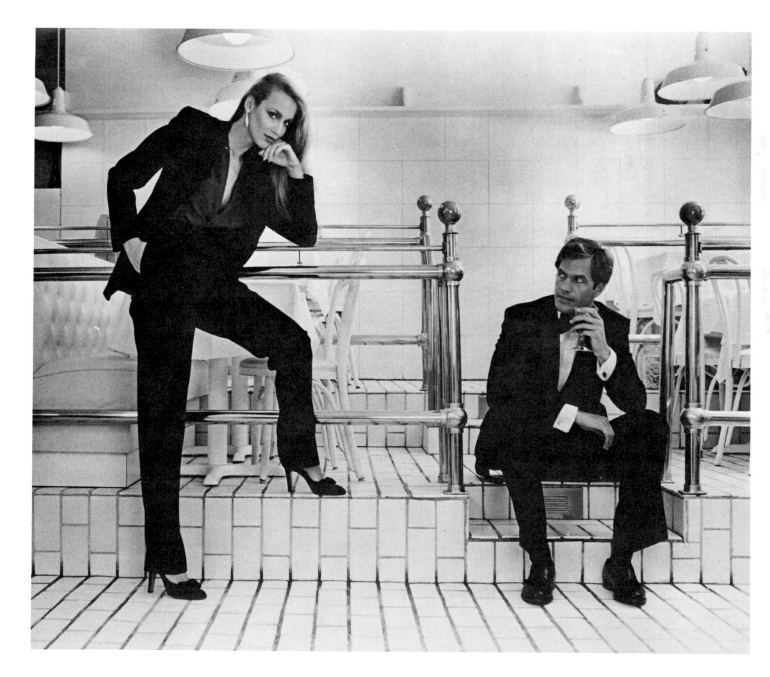

Presenting the Finished Product

The presentation itself is an exciting moment and the cause of much anticipation for the photographer. It should be made, whether in person or sent by messenger, with the same professional attitude that characterized the shooting. If chromes are to be sent, in boxes or slide pages, they should be carefully packaged and marked as to first or second choice.

Often the fashion photographer is asked to shoot pantyhose, socks, gloves, and other articles of clothing that are difficult to present by themselves. But with a little ingenuity—perhaps an unusual camera angle—you can create an exciting photograph.

This is just one more way of making the art director's job an easier one, which in the long run also benefits the photographer. When sending the work by messenger, the photographer should get a receipt from him so that there is no mix-up about where these valuable slides are.

When making the presentation in person, color work can be presented in a slide-projector tray, although it is more likely that the art director will want to spread out the slides in order to compare and make his choices. Even at this stage, the photographer cannot really push for his preferences, but if there is good rapport with the art director and he is not locked into the approach he had originally planned, chances are often good that he will go along with the photographer's ideas. It is my experience that most art directors ultimately do select the photographer's way and, as the working relationship grows, even come to depend on him to devise a fresh and imaginative approach for every job.

Reshoots

At this point, there are still things that can go wrong, raising the specter of having to reshoot the assignment. On a particularly difficult job, I was faced with the possibility that the lab had lost the slides I had sent them to process. There was an imminent deadline, and the client was calling me about delivery while my assistant was on the phone trying to trace the film. The lab claimed that they had no record of ever having received the film, so I had to tell the client that the pictures would be late, knowing they might not materialize at all. Fortunately, the client could wait until after the weekend. We spent all of Friday night and Saturday trying to find a way out of the situation. As a last resort, we asked the lab to look through its garbage, and shortly thereafter the lab called back to say they had found the film (without admitting, of course, that the garbage is where it may have been filed).

While this incident didn't lead to a reshoot, there are as many reasons for a client requesting one as there are things that can go wrong anywhere along the line in an assignment. There are so many details of execution and so many people to please in any shooting that the prospect of a reshoot is not uncommon. Obviously, the cause for a reshoot should not be some simple or gross error on the part of the photographer, for example, the wrong equipment or film, the wrong models, props, or locations, or failure to follow the art director's instructions. Technical mistakes do occur and are the photographer's responsibility, although he cannot be blamed directly. One of my reshoots was the result of bad color processing, which gave the film a greenish cast. The result was not catastrophic, but it distorted the true colors of the clothing shown. The photographer should remember that if there are to be any reshoots, they should not be because he didn't do his job, but because of something for which the client or art director was responsible.

Safeguards. In this respect, the photographer must safeguard himself on every point. The models should be approved by the client and even chosen by him, unless there is absolute understanding and trust between the photographer and client. If the models then turn out to be unsuitable for the product or don't have the right kind of look, the client will have only himself to blame.

Everything should be discussed and agreed upon in advance: location, props, stylists, models, and even lighting. Sometimes, if the lighting is tricky or there is a new kind of setup, it is helpful, especially with strobe, to take Polaroid shots before the actual shooting to get an idea of how the light falls. This can be done by attaching a Polaroid back to the camera being used in the shooting, or by using a Polaroid camera that has manual exposure adjustments. The Polaroid film is not the same quality as that of the final product, so it is sometimes dangerous to show the shots to the client, although there are those who understand what is being done.

Although the photographer should make every effort to shoot a scene his way, to provide an alternative, his first responsibility is to the comprehensive layout or the instructions of the art director. The posing, the amount of space to be left for copy, and the overall look of the picture should be scrupulously worked out, and for this reason the art director should be encouraged at a shooting, and often he

Normally beauty shots are done with soft, even lighting and a light colored background, but using a spotlight can lend a certain drama to the photograph.

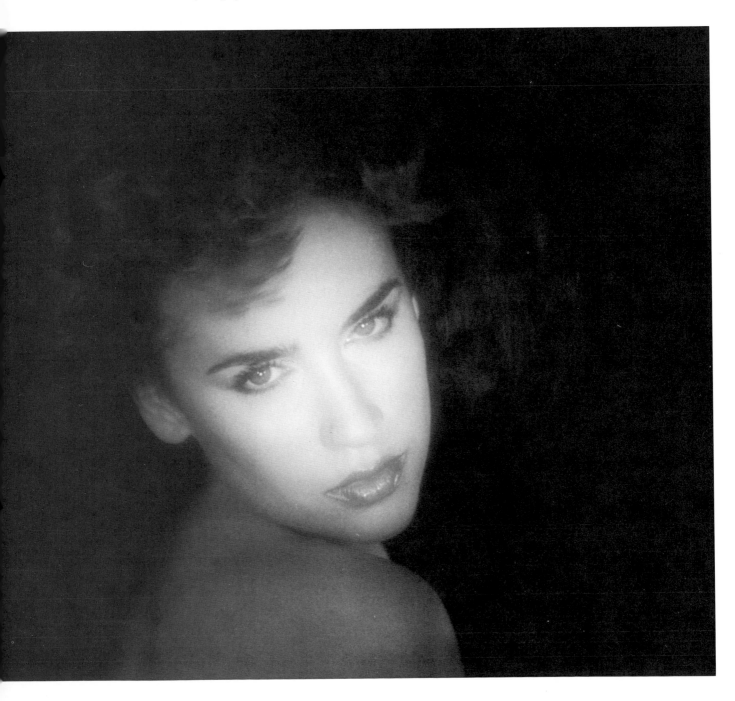

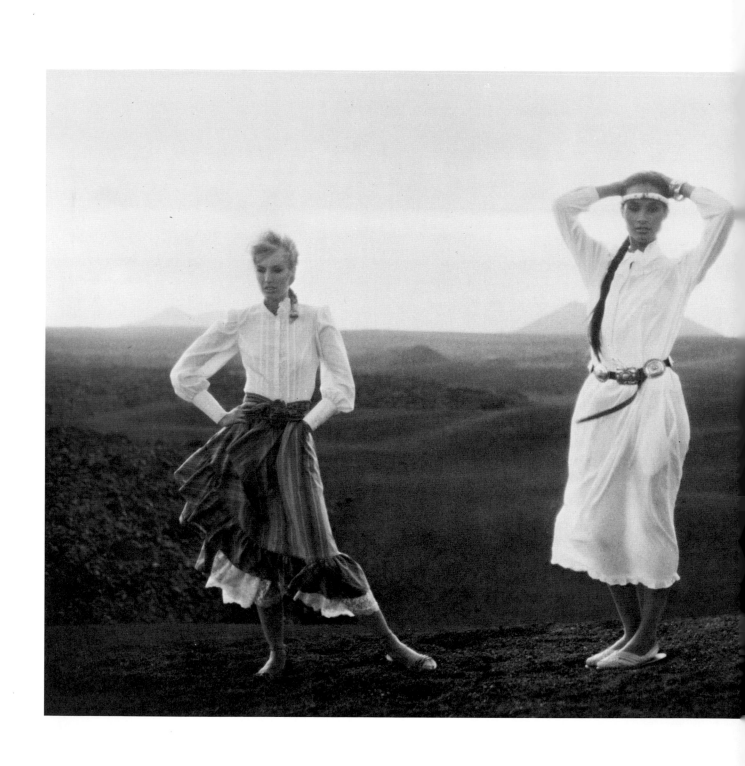

The realization of his own vision is one of the most important rewards that the fashion photographer achieves.

will request, to look through the camera to make sure everything is the way he planned it. Still, the work can meet with disapproval. It may not turn out the way the art director thought it would: the models or the mood may be wrong, the garments may not hang the way they were expected to, or the product may not show up well enough. Sometimes everyone may like it but the one person who has the final say. The ad agency may be excited about a job, yet the client may turn it down. Whatever the reasons for rejection, they should be carefully analyzed by the photographer and avoided if a reshoot is required.

On one reshoot assignment in which I was involved, the decision was made at the client level—by a cosmetics manufacturer. The ad was for nail polish, and the shots showed a pair of hands at a typewriter. When the agency presented them to the client, the latter's reaction was that the typewriter looked too sleek. The feeling was that the electric typewriter we had used should be replaced with a more ordinary, portable model, which would better set off the hands and allow them to be shown working the carriage return. It was one of those subtle things which probably could not have been anticipated but was important enough to the client so that they were willing to cover the expenses for rehiring the model and paying me another fee. For companies with large budgets, the expense of a reshoot means nothing, and in the end it is worth it to them.

One of the problems of reshooting is that, in doing the same thing over again—booking the same models, locations, props, and so forth—there is the danger of losing enthusiasm. There is no new challenge and no room for creativity. The photographer simply has to accept this as a mechanical correction that must be made in order to complete the job. After all, it is another job for which he is paid another fee, unless the fault lay with him. It is to his advantage, therefore, to have in his contract with the ad agency some provision to protect him in case of a reshoot, one that calls for a new fee and the assumption of additional expenses by the client. In some cases, the photographer is paid a percentage of the contracted fee when the job is delivered and the balance after the reshoot. If the job is shelved entirely, he may end up with only a percentage of the agreed upon fee.

A photographer must remember that he cannot always be at his best, although he can always be at his most professional, and to accept that philosophically. A photographer can usually tell if he is doing the best or the worst shooting of his life, and there are days when nothing seems to be right. But this does not necessarily mean that the photographs will automatically turn out badly. There may be an unpleasant situation with an art director or model that tends to color his feeling about the session, but the final product may be perfectly acceptable. If so, the discomfort or lack of rapport is soon forgotten.

Model Cooperation

Occasionally, there may be a complete breakdown in communication, usually when a model becomes difficult and refuses to follow the photographer's directions or won't get into the mood of the shooting. If the situation becomes impossible and the photographer is unable to continue with the model, there is a more drastic solution: to explain the problem to the client and ask to have the shooting cancelled immediately. In this case, he might emphasize his point by even offering to pay the expenses for the model and trying to reschedule another shooting using another model. Fortunately, this rarely happens. Most models are professionals and will put up with a lot in order to see an assignment through successfully—posing for hours under hot lights, modeling bathing suits on a beach in March, overcoming their own personal difficulties or bad moods to do the job right. What the photographer can do, for them and everyone else involved, is to make conditions as comfortable and pleasant as possible.

Making the Pictures Fit

Once the final job has been delivered, there is but one more step in the process of getting it into print—fitting the pictures into the layout. How the art director does this, what he crops out and leaves in, can cause the photographer some anguish, as he usually has a good idea of how he would like the photograph to appear. But unless he is responsible for the total story concept, the photographer has no control over what ultimately happens to his pictures. He has to trust the skill and good taste of the art director—qualities possessed by many of them—overlook those few situations in which the pictures are poorly used, and move on to the next assignment. It will certainly not ruin a portfolio or a career and, if the work is good, and highly praised by agency, client, and public alike, the art director will know whom to credit—in other words, who played the major role in creating and executing an ad or editorial layout.

Fashion Photography

In the light of good work, problems tend to disappear, and that is the way to look at the entire field of fashion photography. Problems are to be expected when there are so many factors and creative people involved, but the problems are momentary, while the work itself is permanent. The excitement of the field itself— the glamour, the constantly changing styles, the extraordinary aesthetic possibilities—more than compensates for the occasional volatile or tedious situations. With forward-looking art directors and adventurous photographers, the work continually renews itself and provides its own best reward in the realization of one's own vision. The path is sometimes difficult, but loyalty to that vision is the key to a successful and satisfying career in fashion photography.

List of Models

The following models appear in the book:

Kim Acee
Carol Alt
Annette
Apollonia
Anne Bezamat
Richard Basic
Libby Bean
Beatte
Erik Boer
Christie Brinkley
Lynn Brooks
Bobbi Burns
Gerri Carranza
Shaun Casey
Colette Christie
Clotilde
Constance
Erika de Kobal
Nancy Decker
Debbie Dickinson
Janice Dickinson
Nancy Donahue
Margaret Donohoe
Jill Duis
Gia

Susan Gentry
Brian Grant
Christian Gregory
Nancy Grigor
Jerry Hall
Lori Hamilton
Peter Hans
Patti Hansen
Maria Hanson
Dee Hart
Karen Howard
Iman
Ingo
Beverly Johnson
Jill Johnson
Jack Krenek
Denis La Marsh
Joe MacDonald
T. James McCavitt
Terry May
Eva Malmstrom
Chris O'Connor
Patti Oja
Caren Peyton
Nancy Pianta

Amanda Porter
Kathy Quirk
Margaret Ramme
David Roman
Lise Ryall
Jane Lee Salmons
Tony Sanchez
Leslie Sank
Michele See
Joan Severance
Sally Sharp
Richard Smith
Martin Snaric
Kim Stevenart
Michelle Stevens
Lisa Vale
Valentine
Vibeke
Suzanne Von Schaack
Rachel Ward
Nickey Winders
Clif Whitehead
Toby Wolter
Eva Voorhis
Yolande

Index